IMAGES
of America

CHIPPEWA FALLS

WISCONSIN

10642599

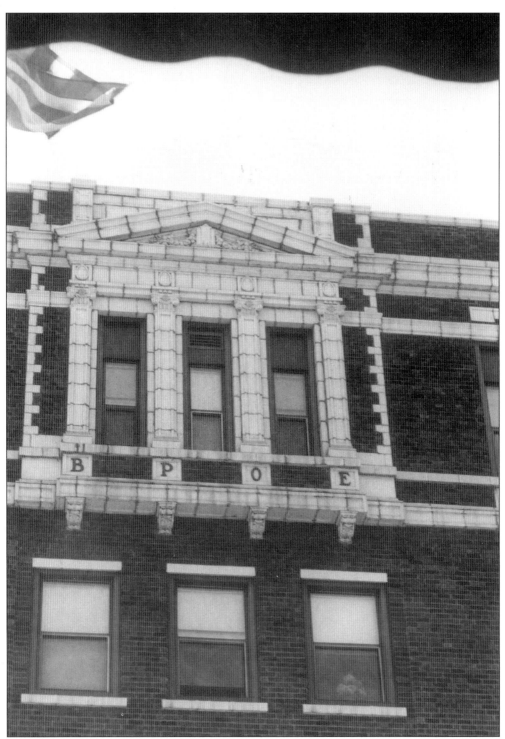

The decorative lettering on the fifth story of the old Hotel Northern, currently the Northern Apartments, stood for Benevolent Protective Order of Elks, but we prefer the translation "Best People on Earth."

IMAGES
of America

CHIPPEWA FALLS

WISCONSIN

Chippewa Falls Main Street, Inc.

Evalyn Frasch
Lucyann LeCleir
Jim Schuh
Nancy Schuh

ARCADIA

Copyright © 2001 by Chippewa Falls Main Street, Inc.
ISBN 0-7385-1931-6

Published by Arcadia Publishing,
an imprint of Tempus Publishing, Inc.
3047 N. Lincoln Ave., Suite 410
Chicago, IL 60657

Printed in Great Britain.

Library of Congress Catalog Card Number: 2001093319

For all general information contact Arcadia Publishing at:
Telephone 843-853-2070
Fax 843-853-0044
E-Mail sales@arcadiapublishing.com

For customer service and orders:
Toll-Free 1-888-313-2665

Visit us on the internet at http://www.arcadiapublishing.com

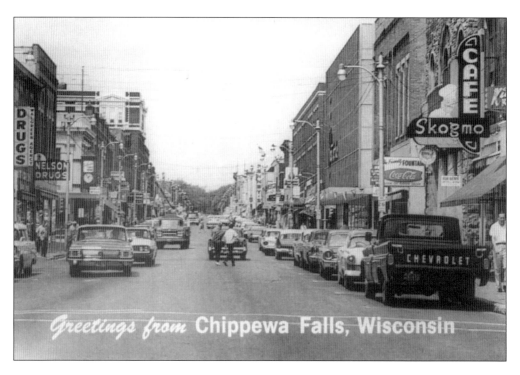

CONTENTS

ACKNOWLEDGMENTS

While gathering information and photos for this book, we truly got to experience the "Best People on Earth." We express our great appreciation to all of the following individuals, organizations, and businesses which gave generously of their time, guidance, knowledge, skills, and resources. We could not have done it without you.

Seyforth's Studio and Camera Shop	*The Chippewa Herald*
Chippewa County Historical Society	Delores Beaudette
Chippewa County Genealogical Society	Charles Schaaf
Rutledge Home For The Aged—Pat Hrdlicka	Dave Varga
Rutledge Charity—Betty Manning	Dick Feeney
Heyde Center For the Arts—Jeff Monette	Brenda Marlow
Chippewa Valley Museum	Mary Brown
Chippewa Falls Museum of Industry and Technology	Chippewa Falls Public Library

We also thank everyone who contributed photos. There were many difficult decisions about what to include, and with the limited space available we were unable to use all of them. Chippewa Falls' history is long and our book is relatively short.

Photo credits are noted with each picture. For the purpose of brevity, we have abbreviated the following organizations' names:

Chippewa County Historical Society	(CCHS)
Chippewa Falls Main Street, Inc.	(CFMS)
Chippewa Valley Museum	(CVM)

Chippewa Falls is a shining example of what can be achieved when individuals, organizations, and businesses work together to preserve historic sites and structures.

The Chippewa Falls Main Street Board of Directors, staff, and volunteers hope you will enjoy this publication. We are dedicating this book to the diverse groups and individuals who came together in the past to create the present community of Chippewa Falls.

INTRODUCTION

This pictorial history of Chippewa Falls attempts to document the cultural, economic, political, and social history of a community carved from lands ceded by Native Americans to the federal government in 1837. Reflecting the diversity of the Chippewa Falls community, this book intends to be inclusive, with each photograph telling a story about an individual, an event, a building, or a place—all of which are part of this community's collective history.

Long before Columbus "discovered" America in 1492, and long before Jean Brunet, Louis Demarais, Hiram S. Allen, Jacob Leinenkugel, Edward Rutledge, August Mason, and William Irvine were associated with Chippewa Falls, Native American people hunted, fished, and gathered the abundant food supplies of the Chippewa area. Paleo-Indians entered Wisconsin about 11,000 years ago as the glaciers receded. The Archaic Indians moved into Wisconsin about 6,000 B.C. and developed raw copper for multiple uses, including knives and trade goods. Discovered in 1989, the "Pearson's Ridge 111" site along the Chippewa River contained artifacts used more than 4,000 years ago by a small group of Native Americans who camped on the high banks. A mound on the George Mishler farm, opened in 1852, filled with considerable quantities of flint chisels, arrowheads, and many small shells, was a disappointment to the local populace, because there were no human remains. The complex role of Native Americans in the history of Wisconsin and of Chippewa Falls was diminished as they were steadily displaced by a white society eager to carve out a community amidst a seemingly endless supply of natural resources. However, the history of Chippewa Falls would be incomplete without acknowledging the significant contributions of Native Americans to this community which, in fact, continue to the present time.

The Ojibwa people began a 500-year journey from "somewhere on the shores of the Great Salt Water in the East," which concluded on Madeline Island about 1394. In 1767, British explorer Jonathon Carver reported that every summer, Ojibwa from Northern Wisconsin met with fur traders at "the Falls," a place which, when recorded on his map, became one of the earliest records of Native American activity in the Chippewa Falls area. Michael Cadotte, a French-Canadian-Ojibwa fur trader, set up a trading post south of the Falls in 1797. The first sawmill appeared in 1838, ushering in the lumber era, which became a major impetus to the community's commercial growth, boosting the population, and attracting the Allens, Rutledges, Irvines, Marshalls, and McDonells.

When the largest sawmill under one roof closed in 1911, the Progressive League was successful in attracting many diverse industries to Chippewa Falls. The "Made in Chippewa" label became synonymous with superior quality products from shoes to gloves, candy to cigars, cabinets to coaster wagons. In the early 1950s, the fledgling plastics industry eventually spawned over a dozen plastics related businesses. When Seymour Cray returned to his hometown in the late 1960s to design and build supercomputers, the "Made in Chippewa" label took on new meaning.

Chippewa Falls has been home to philanthropists, elder statesmen, military heroes, creative individuals, and hard-working immigrants, all of whom have contributed to the development of the community. Chippewa Falls has a wealth of historic resources in its buildings, its people, and its industries. The purpose of this pictorial history of Chippewa Falls is to portray a multifaceted community that has not lost touch with its past and is committed to preserving its uniqueness well into the future.

CHIPPEWA FALLS

Since the long vanish'd ring of the axe on the pine
And the voyage of lumber down stream
This fair little city of yours and of mine
Has been dreaming a beautiful dream.
But see! It is waking! It throws off the Past
And the Present comes forward and calls!
There's a name that will shine and a fame that will last
For the city of Chippewa Falls!

II.
Like a glittering gem on an emerald gown
It shines in its fair Summer nest
Where the Chippewa River goes wandering down
To the crimson and gold of the West.
'Tis rising from the slumber and feeling new life
In its thoroughfares, markets and halls.
In the years 'round the Bend there is fame without end
For the city of Chippewa Falls!

III.
Fair Garden of Childhood! Fair home of today!
Not in vain are its beauties displayed!
Nor shall one of these beauties give place to decay
Nor shall dust choke its channels of trade!
'Tis a city of story, a city of song,
And within its fast-widening walls
Are the same hearts of gold that beat fondly of old
For the city of Chippewa Falls!

William F. Kirk
Chippewa Falls poet
(1877–1927)

One

IN THE BEGINNING

At the confluence of Duncan Creek and the Chippewa River, a community took root during the fur-trading era and grew up during the lumbering era. At first carried on by men of small means, prosperity came to those who persevered through floods and fires and financial disasters.

Michael Cadotte succeeded his French-Canadian father and Ojibwa mother in the fur trade when he set up a fur trading post on the south bank of the Chippewa River in 1797. He married Equaysayway, the daughter of the hereditary chief of LaPointe. After her conversion to Catholicism, Chief White Crane named his daughter Madeline. The Cadotte's two daughters, Mary and Charlotte, married two brothers, Lyman and Truman Warren, and in 1823, Michael Cadotte sold his business in the Ojibwa trade to his sons-in-law. The Warrens were contemporaries of Jean Brunet, Louis and Angeline Demarais, and Hiram Allen, all of whom, beginning in 1836, were building the sawmills that marked the beginning of Chippewa Falls. In 1874, Geneve Cadotte, granddaughter of Michael Cadotte, married Francis LaRush in Chippewa Falls. Descendants of Equaysayway and Michael Cadotte are members of the Chippewa Falls community today.

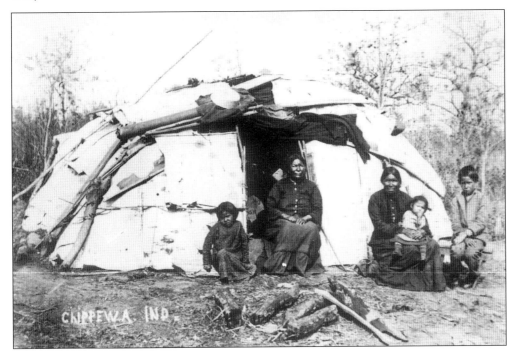

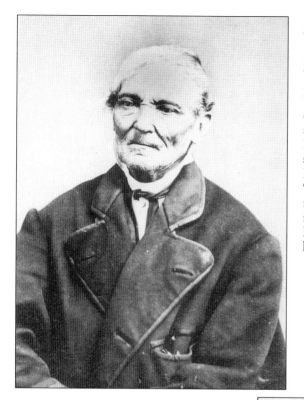

Jean Brunet was born in Gascogne, France, in 1791. After coming to this country, he moved to Prairie du Chien. In 1836, he was hired by Hercules Dousman of the American Fur Company to oversee the construction of a sawmill on the river at Chippewa Falls. The mill would later be referred to as the "largest sawmill under one roof." William Irvine described Brunet in 1926 as a "dignified, courtly gentleman, full of interesting information which he imparted graciously and intelligently. It was always a pleasure to talk to him." (Courtesy of Rutledge Home.)

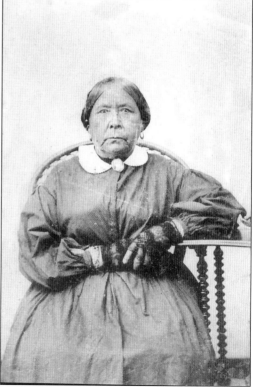

Angeline Quarla Demarais, the French and Native American wife of Louis Demarais, was remembered by her contemporary, Thomas Randall, as the county's first physician "of uncommon natural abilities, and with education and culture would have graced a high social position in any community." She died in 1882, at the age of 110 years. (Courtesy of CCHS.)

Marie Demarais Allen, the oldest daughter of Angeline and Louis, married Hiram Allen in 1838 in Chippewa Falls, where both were held in high regard by the Ojibwa bands. Marie was a devout Catholic and the mother of 11 children. When she died in 1894, Notre Dame was filled with her old acquaintances. (Courtesy of CCHS.)

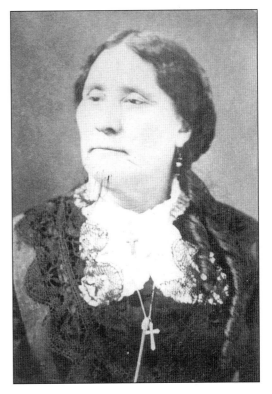

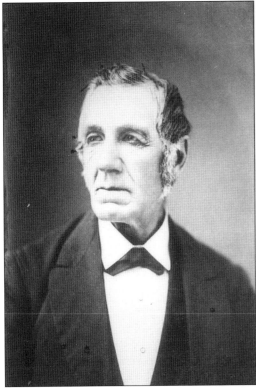

Hiram Storrs Allen was identified with every public enterprise, from building steamboats, sawmills, roads, and railway lines, to establishing stage lines. He was the "father" of Chippewa Falls and was a keen businessman and hard worker. When he died in 1886, the mayor's proclamation closed every business in the city on the day of the funeral. (Courtesy of CCHS.)

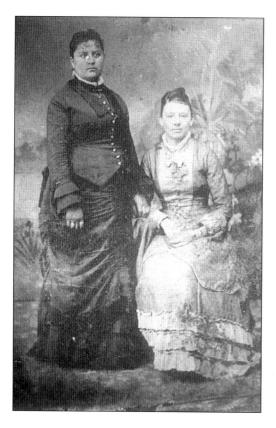

Margaret Demarais Trepanier and Mary Trepanier Ferguson, the daughter and granddaughter of Angeline and Louis Demarais, and the wife and daughter of Joseph Trepanier, a logger in Chippewa Falls, are pictured here. (Courtesy of CCHS.)

George P. Warren, grandson of Michael and Madeline (Equaysayway) Cadotte and a capable farmer in the Chippewa area, married Rosalie Demarais. A Civil War veteran, Warren made frequent trips to Washington, D.C., as an Ojibwa interpreter. President Lincoln called him the "cleverest and best informed man of Indian blood" he had ever seen. (Courtesy of CCHS.)

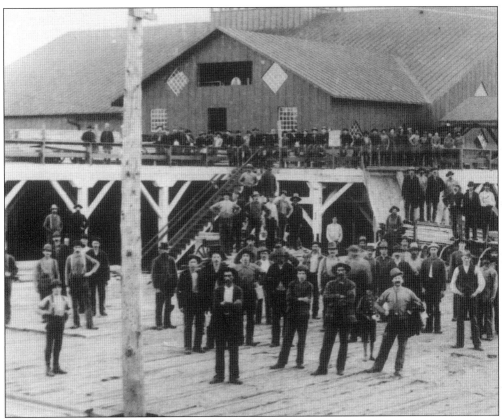

The mill was the very beginning of Chippewa Falls, which depended on its continued operation for growth. After surviving floods and foreclosures, Frederick Weyerhaeuser turned the Chippewa Lumber and Boom Company mill into the largest sawmill under one roof in the world. (Courtesy of CCHS.)

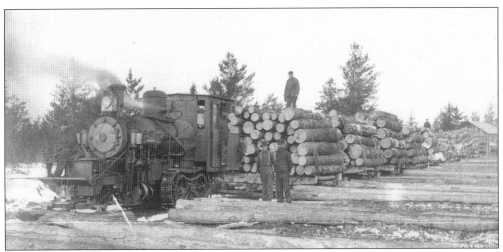

Railroad lines connected Chippewa Falls to the vast lumber region extending 160 miles north to Lake Superior. The Phoenix steam powered log hauler moved logs out of the woods to the nearest railroad line. (Courtesy of Rutledge Home.)

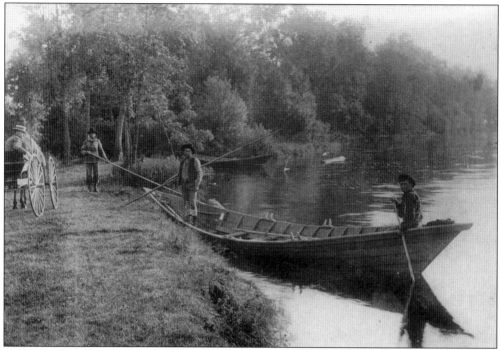

Bateau boats and their crews were required to spend long days on the river driving logs downstream. Driving was the most dangerous of all logging operations, and workers received $3 a day for the difficult work. (Courtesy of CCHS.)

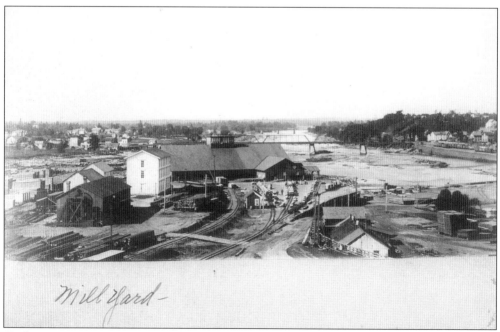

mill yard

With 90 saws in motion at one time, the mill yard was frequently full of lumber, shingles, and laths, produced by mill workers earning $1 a day. (Courtesy of Rutledge Home.)

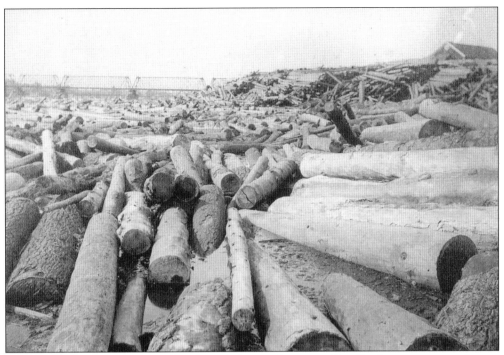

Logjams were common as sawed lumber piled up in the rivers. Usually they gave way and came downriver without loss; however, sometimes bridges and dams were carried away by a jam of logs. (Courtesy of Delores Beaudette.)

This two-story clapboard structure with a false front, built in 1859 by Peter Morie, was the building in which local residents registered for the Civil War. The extant wood building survived the devastating fire of 1869, and is the oldest commercial building in the downtown. It is presently owned by Joe Joas. (Courtesy of CFMS.)

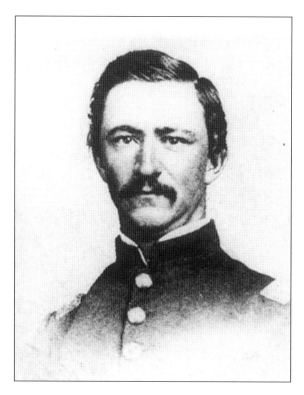

Hollon Richardson, then the prosecuting attorney of Chippewa Falls, was the first man from Chippewa County to enlist in the Civil War. He became a lieutenant colonel commanding the Seventh Wisconsin of the Iron Brigade. Returning to Chippewa Falls after the war, he resumed his law practice and served his city in many capacities. (Courtesy of CCHS.)

John J. Jenkins enlisted with the Sixth Wisconsin Volunteer Infantry, a part of the Iron Brigade, beginning a life of public service. During his lifetime he was a lawyer, a city attorney, a county judge, and a member of the U.S. Congress for 14 years. He was also appointed judge of the highest court in Puerto Rico. (Courtesy of Evalyn Frasch.)

Old Abe, the War Eagle, captured in 1861 near Lac du Flambeau and sold to Dan McCann for a bushel of corn, was the inspiration for the Eighth Wisconsin Volunteer Infantry during the Civil War. When a battle began, he spread his wings, "uttering his startling scream, heard, felt, and glorified in, by all the soldiers." (Captain Charles H. Henry, 1933.) (Courtesy of CCHS.)

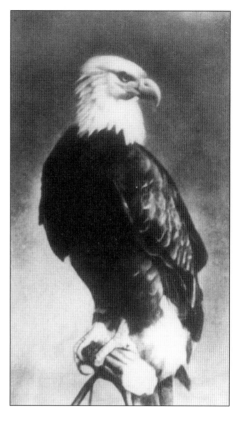

This autographed photo of Abraham Lincoln was presented to Ira Isham, an interpreter for the Native American community and a constable of Chippewa Falls. (Courtesy of Rutledge Home.)

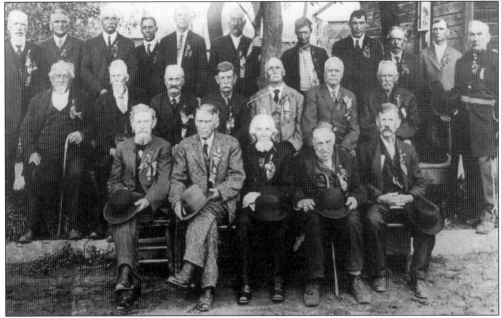

Civil War Veterans, wearing their decorations, gathered prior to 1915. Forty-five soldiers from Chippewa County died in service, including two grandsons of Michael and Madeline Cadotte. From left to right are: (bottom row) H.M. Stuart, Henry McWethy, Pliny Ellis, Adam Mohr, George Treat; (middle row) George Schlenk, Dan McCart, Phillip Burke, J.E. Andrews, Wm. Hillman, E.M. Emerson, Frank Bugby; (back row) E.F. Cutting, A.J. Clark, unidentified, unidentified, Bill Waugh, G.W. Lane, W. Pritchard, unidentified, John Bungartz Sr., unidentified, and Joe Barcume. (Courtesy of John Bjerke.)

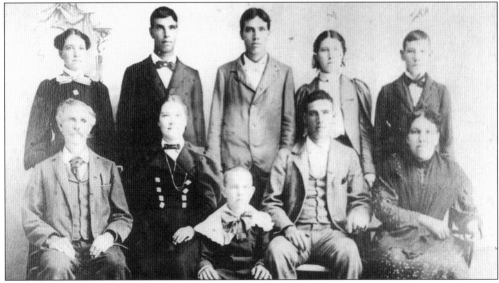

Sophie LaRush Martin, seated far right, was a direct descendant of Michael and Madeline Cadotte. In 1872, she married Myron Martin (first row, far left), who owned a second-hand store in Chippewa Falls. To her right is son Frank Martin, father of Caroline Martin Benson, an Ojibwa poet and storyteller. (Courtesy of Marge Hebbring.)

Two

CREATING A
COMMUNITY

When William Irvine came to Chippewa Falls in 1865, there were less than a thousand people. Spring Street was the main street, and there was nothing but the mill. "The clear river, the genial people and the delicious odor of pine sawdust everywhere completely captivated me. I immediately fell in love with the country and have never experienced a change of heart to this day."

Many immigrants brought with them the traditions of their former lives, and the first generations carried on businesses, which supported and complimented the lumber industry. They built churches, schools, banks, rooming houses, huge hotels, breweries, bottled water plants, ferries, and steamboats. They made harnesses, cigars, beer, shoes, and mackinaws. They were concerned about religious education and the health of the community. Chippewa Falls built an interurban railway, a library, post office, hospitals, a jail, a courthouse, and its most generous citizens created a park, a home for the elderly, and a Catholic high school. William Irvine concluded that Chippewa Falls during this time was "no place for a lazy man." (William Irvine interviewed by Alexander Wiley, 1923.)

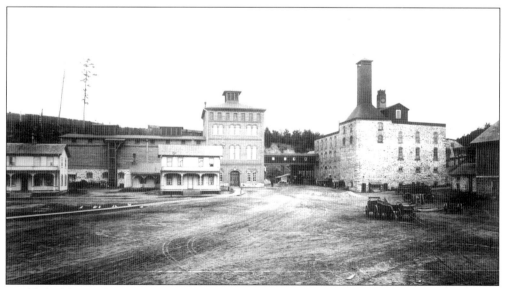

Established by Jacob Leinenkugel in 1867, in partnership with John Miller, the Spring Brewery produced 400 barrels of Spring beer annually. Renamed Leinenkugel's Spring Brewery in 1883, this brewing company is the industry with the longest continuing history in Chippewa Falls. (Courtesy of CCHS.)

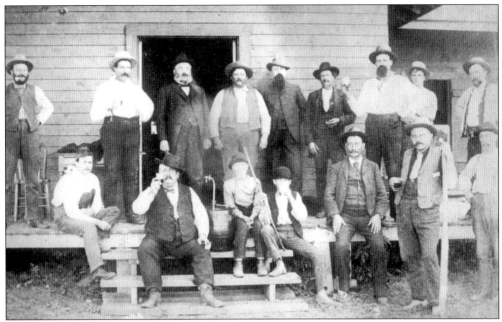

Jacob Leinenkugel, seated on the steps, was more than the brewer of Leinenkugel's beer. Described as a noble, magnanimous man and a generous contributor to Notre Dame Church, he served two terms as mayor. During his term in 1881, the streets of the city were switched from gas to electric lights. (Courtesy of CCHS.)

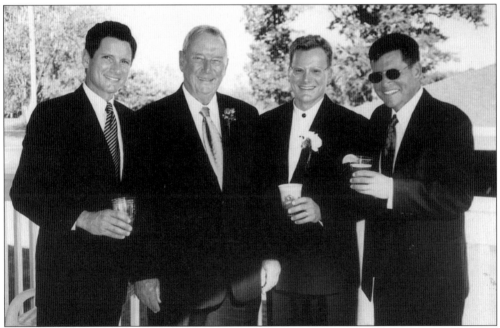

The fifth generation of the Leinenkugel family carries on the tradition of overseeing the brewing process, marketing their famous product, and supporting the community of Chippewa Falls. Pictured from the left are Richard Leinenkugel, father William Leinenkugel, John Leinenkugel, and Jake Leinenkugel. (Courtesy of Leinenkugel Brewing Co.)

Father Charles Francis Xavier Goldsmith, born in New York, educated in Milwaukee, and ordained as a priest in Belgium, arrived in Chippewa Falls in May 1869. One of his first acts was to appoint a building committee to oversee the construction of a new church to replace the small wood framed St. Mary's Church. Father Goldsmith toured lumber camps to raise funds or pledges of labor and material from the workers and drew up plans for the new church. (Courtesy of CCHS.)

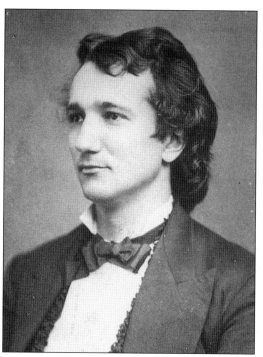

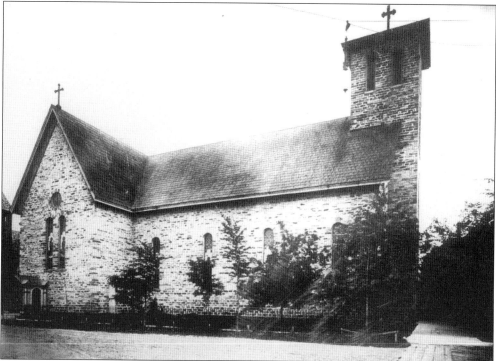

Completed in 1872, St. Mary's was renamed Notre Dame in 1884. It is the only church in the area built entirely of local stone. The dedication ceremony was witnessed by at least 3,000 people for whom sermons were given in English, French, and German. Notre Dame became the mother church for 18 churches and chapels. (Courtesy of CCHS.)

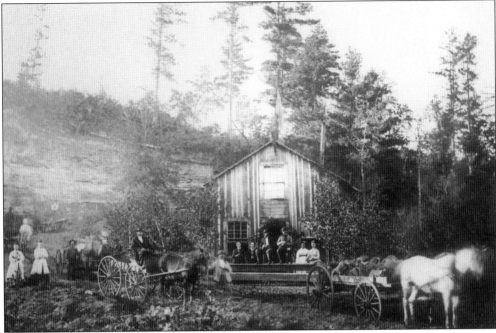

The sandstone of the outside walls of Notre Dame came from the quarry of Malarkey and McGuirk, pictured here. Reported to be along Duncan Creek on the east side of what is now Irvine Park, the quarry also furnished stone for Leinenkugel Brewery and the Lister house at 606 West Willow Street. (Courtesy of Rutledge Home.)

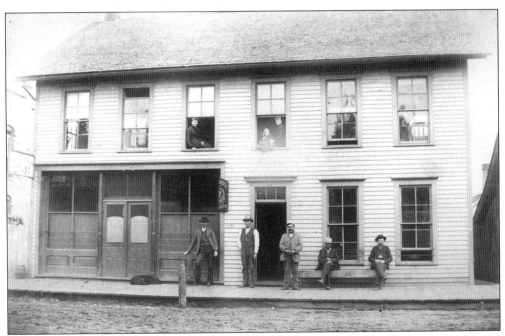

In 1874, Alex Wiley built The Norway House in a swampy area halfway between Bridge and Bay Streets. It became a landmark for new settlers from Norway and for lumbermen who came down from the woods in the spring. (Courtesy of Evalyn Frasch.)

L.C. Stanley was one of the notable business people of Chippewa Falls. Through his efforts, the city was given its first railroad, which he managed for over 10 years. He served as mayor in 1881, as a school board member, and as president of the First National Bank. (Courtesy of CCHS.)

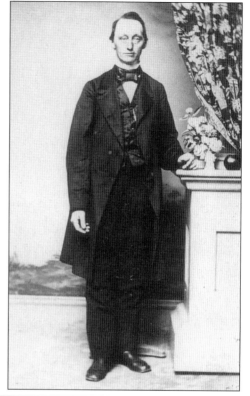

The Stanley House grew out of the Waterman House, which had been rebuilt after a fire in 1872. L.C. Stanley purchased the hotel located on the corner of Bridge and Mill, now Grand Avenue, in 1882. He remodeled the building, built an addition, and renamed it the Stanley House. (Courtesy of CCHS.)

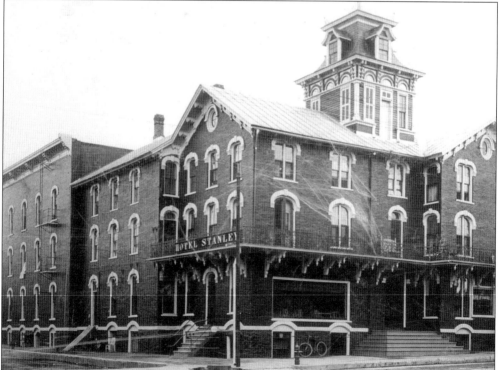

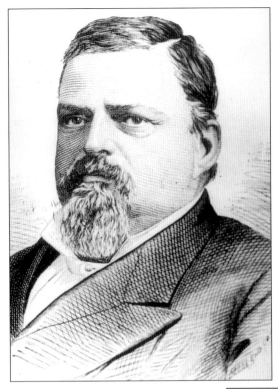

George C. Ginty published the first issue of the *Chippewa Herald* on January 29, 1870. The *Herald* was a weekly newspaper until June 25, 1894, when it became a daily. Lee Enterprise currently owns the *Chippewa Herald*, and Mark Baker serves as editor and publisher. (Courtesy of CCHS.)

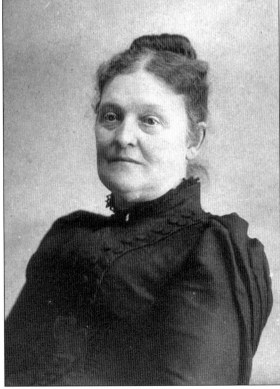

Before the *Washington Post* had Katharine Graham, the *Chippewa Herald* had Flora Ginty. After Mr. Ginty's death on December 9, 1890, his wife Flora took over editing and publishing the *Chippewa Herald* until February 12, 1892, when the Herald Printing Company was formed. (Courtesy of Rutledge Home.)

Local governmental entities met in several buildings throughout Chippewa Falls before the county erected a building in 1860, for use as a courthouse and jail. In 1872, a second courthouse, constructed at Court House Square, served the county until it was replaced in 1950. Daniel Frederick Hoenig was a blacksmith and wagonmaker until elected sheriff of Chippewa County in 1876. He was also the first city marshall. (Courtesy Rutledge Home.)

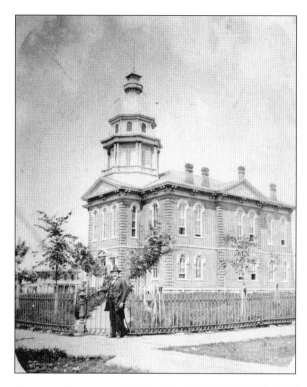

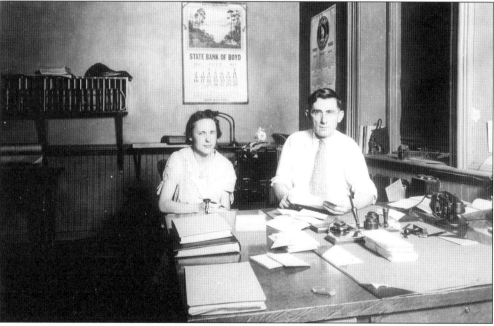

The courthouse was a substantial structure built at the contract price of $37,000. With a basement that could be used as a jail and a 24-foot courtroom, the offices were described as "large and convenient." In the county treasurer's office are Secretary Louise Martineau and John Kelly, who from 1922–1924 was one of the longest serving county treasurers. (Courtesy Mary Anderson.)

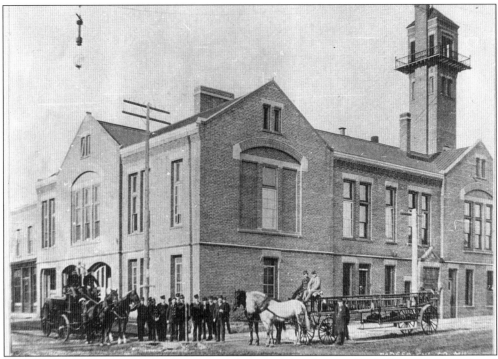

The first Chippewa Falls City Hall was destroyed by fire in 1883, but it was replaced immediately by this brick two-story structure. Housing the fire department as well as the city offices, the city hall was characterized by a tower designed for hose drying and observation. (Courtesy of Rutledge Home.)

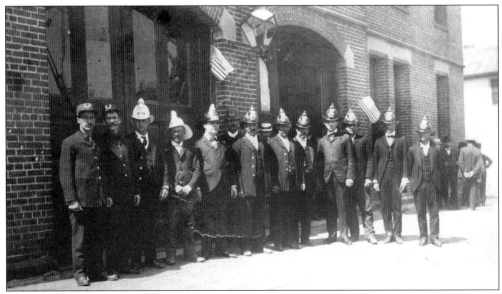

The Chippewa Falls Fire Department, c. 1900, started as a volunteer fire brigade. Their fire fighting apparatus consisted of a Silsby steamer rotary engine named the *James A. Taylor* after the first mayor, a village hook and ladder, four small Babcock hand fire extinguishers, and 1,000 feet of hose. (Courtesy of CCHS.)

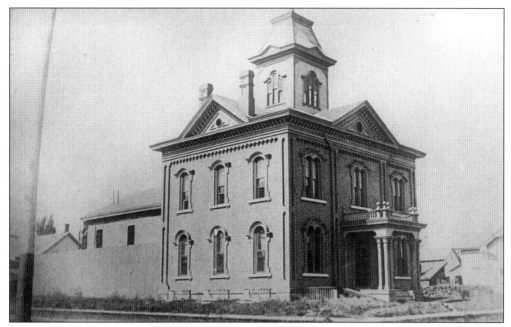

The cornerstone for the Chippewa County Jail was laid in 1875. Built on Spruce Street across from the courthouse, it was far more elaborate than H.S. Allen's root cellar, which had served as one of the first jails. The first local law enforcement official was probably Moses Rines, who was elected county sheriff at the first county board meeting in 1854. (Courtesy of CCHS.)

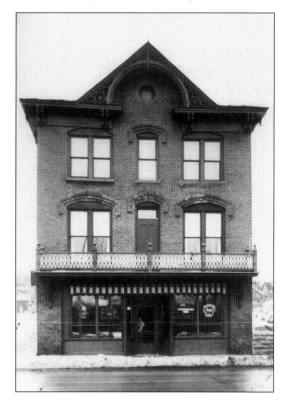

Taverns were connected with many early boarding houses such as the Sheeley House, remodeled by John Paul in 1884. It is the city's best preserved commercial structure influenced by the Italianate Revival style. (Courtesy of CCHS.)

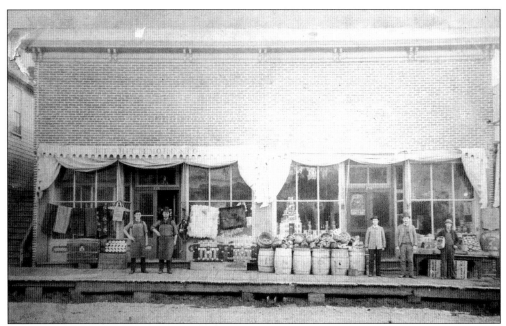

Robert D. Whittemore came to Chippewa Falls in 1872, and was employed by the Union Lumber Company until purchasing the harness shop at 221 North Bridge. From left to right are: Joe Poquette, Al Olson, Van Monat, John Evans, and R.D. Whittemore. (Courtesy of Rutledge Home.)

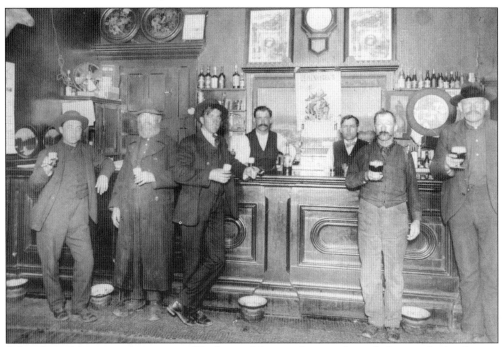

Schindler's Saloon, on the corner of Bridge and Spruce Streets, depended upon the lumbering trade for the majority of its business. When this picture was taken, there were only 35 smoke-filled saloons left in the city, down from a peak of 85 in 1880. (Courtesy of CCHS.)

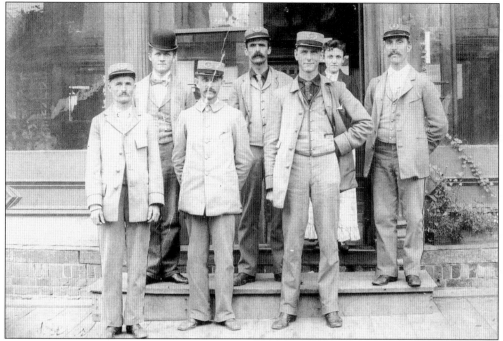

The first mail carrier system within Chippewa Falls was organized in 1889, 34 years after H.S. Allen was appointed first postmaster. Pictured in 1893 are, from left to right: (front row) Henry Hebert, Robert L., Mike Thornton; (second row) Gus Brice, Lars Norway, Liddell, and John Parent. (Courtesy of Rutledge Home.)

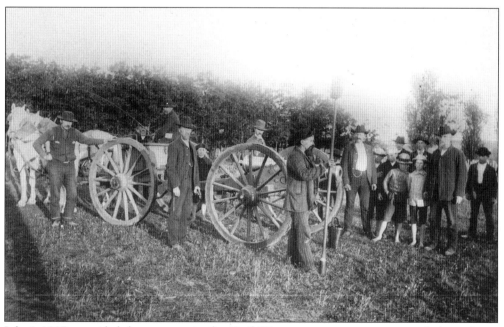

July 4, 1897, provided the opportunity for Civil War veterans to commemorate Independence Day. Some of the gentlemen are believed to be members of the James Comerford Post, No. 68, which at one time was the largest in the state. (Courtesy of Rutledge Home.)

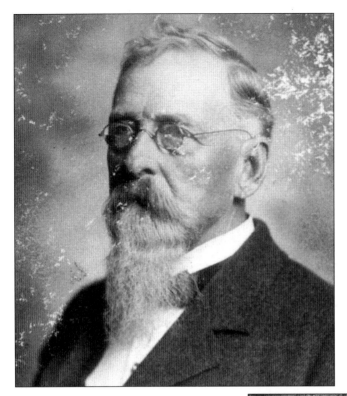

Thaddeus Pound, who built the first house on Bridge Street on the lot now occupied by the Metropolitan Block, was a businessman, lieutenant governor, and congressman who believed the spring water on his farm had health-providing properties. Thad Pound became as well known for his mineral water as he was for being the grandfather of Ezra Pound, who wrote the poem *The Legend of the Chippewa Spring and Minnehaha*. (Courtesy of Rutledge Home.)

The original Spring House was dedicated on August 24, 1893. The Spring House covers the original spring, which had the capacity to produce 20,000 gallons of mineral-free water a day, water that never varied in temperature. It has been placed on the National Register of Historic Places. (Courtesy of CCHS.)

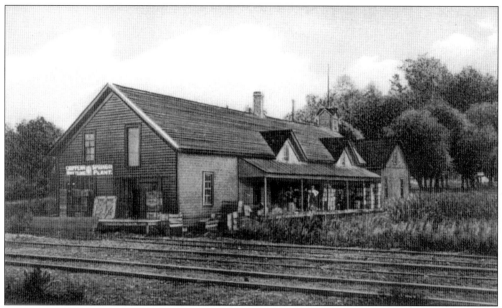

Chippewa Mineral Spring became Chippewa Spring Water Company when it was sold in 1903. At that time, Thaddeus Pound was president and was shipping Chippewa Spring Water by tank cars and bottled water by rail to all parts of the United States. (Courtesy of CCHS.)

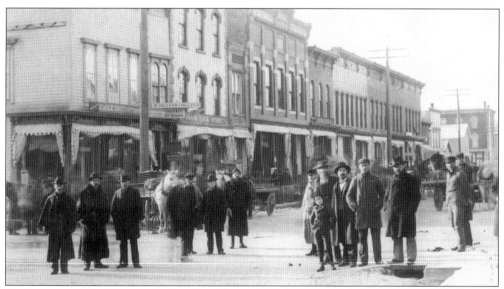

Early stores and buildings, which at first clustered along the banks of the Chippewa River, later expanded into the Spring and Bridge Street commercial area. Spring Street, in 1897, was lined with businesses that reflected the diverse needs of a growing population. (Courtesy of CCHS.)

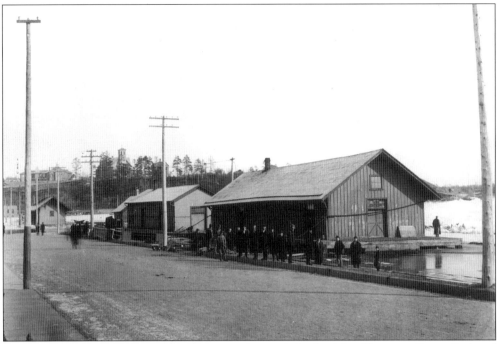

River Street was the first commercial area on the north bank of the Chippewa River. Railroad lines along River Street stretched to the sawmill and stopped at the foot of Catholic Hill. Flooding was so frequent that the railway station was lashed to the ground to prevent it from floating away. (Courtesy of CCHS.)

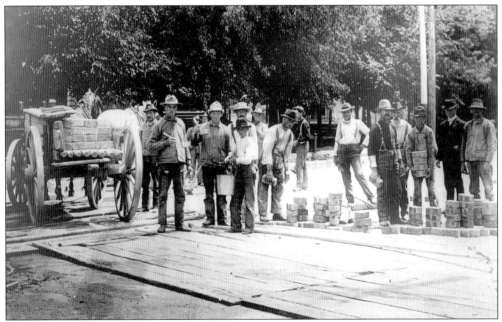

Bridge Street was paved with cedar blocks until 1903, when the city council authorized re-paving with brick the two blocks of Bridge Street between Spruce and Elm Streets. Soon cement and brick sidewalks superseded the plank walks all over the city. (Courtesy of CCHS.)

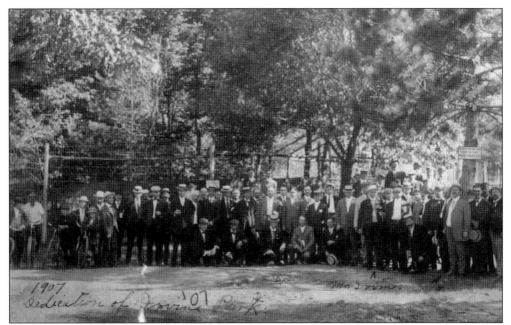

The dedication of Irvine Park in 1907 was just the beginning of a philanthropic effort by William Irvine to set aside land for a public park. He continued to donate land "for the sum of $1" to the City of Chippewa Falls for the park, and he paid for a pavilion, concerts, and for a bandstand, a memorial to soldiers and sailors of all wars. L.C. Stanley donated land, and A.B. McDonell donated the use of the lake, Glen Loch, to Irvine Park. (Courtesy of Rutledge Home.)

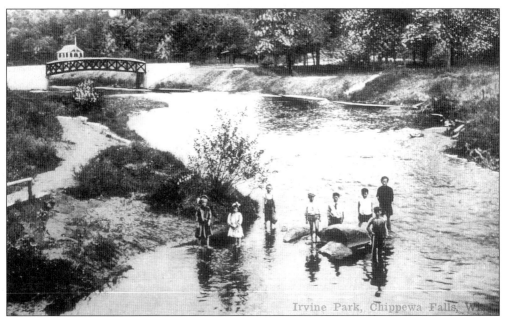

While children waded in the waters of Duncan Creek, many other people eagerly awaited the Sunday afternoon concerts in the park, which were financed by William Irvine for 11 years. (Courtesy of CCHS.)

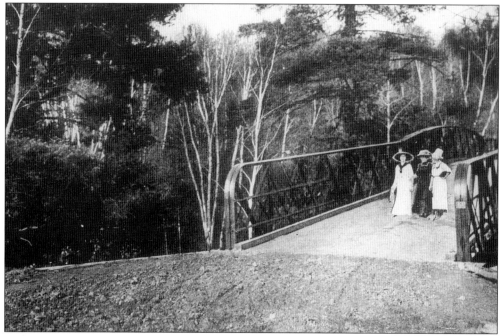

In 1914, William Irvine agreed to underwrite the cost of a steel bridge of three spans over a ravine in the park. Costing $4,000 and named the Bridge of Pines, it connected the north section of the park to the south end, 1 1/2 miles away. The bridge was nicknamed the "Rumbly Bridge" by later generations. (Courtesy of CCHS.)

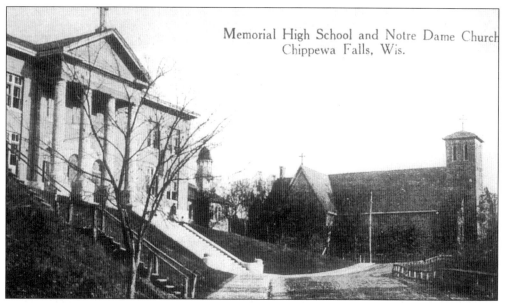

In 1881, Father C.F.X. Goldsmith notified the city that the Notre Dame parish wished to take full responsibility for instructing its children. In 1908, benefactor Alexander McDonell provided funds for the construction of McDonell Memorial High School. McDonell owned some of the finest tracts of pinelands, often having seven lumber camps operating in the winter, and was a founder of the Lumberman's National Bank. (Courtesy of CCHS.)

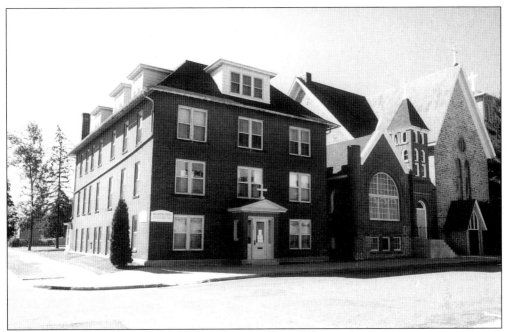

Ten teaching sisters of Notre Dame arrived on September 25, 1881, to begin instructing both public and parochial students in a school on the site of the Notre Dame Convent. Today the convent houses the Chippewa County Historical Society and Genealogical Society. Between the convent and Notre Dame Church is the Goldsmith Chapel, where beneath the altar, Father C.F.X. Goldsmith is buried. (Courtesy of CCHS.)

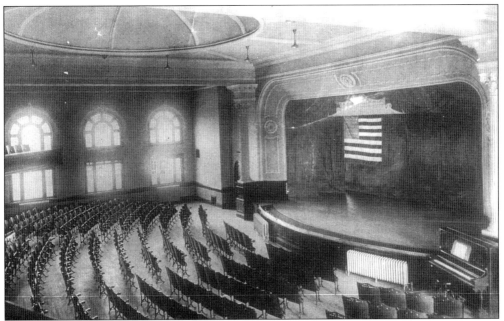

The 330-seat auditorium of the old McDonell Memorial High School is now the showcase of the Heyde Center of the Arts. The auditorium's quality acoustics enhance the sound of each musical and stage performance. (Courtesy of CCHS.)

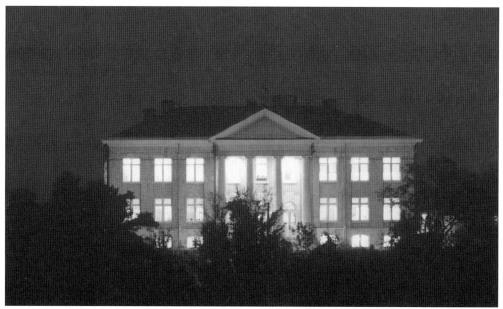

After an extensive restoration made possible by $1.2 million in donations, McDonell Memorial High School has become the Heyde Center for the Arts and is the home of the Chippewa Valley Cultural Association. The center, under the direction of Jeff Monette, has become one of the most renowned cultural arts centers in Wisconsin. (Courtesy of the Heyde Center for the Arts.)

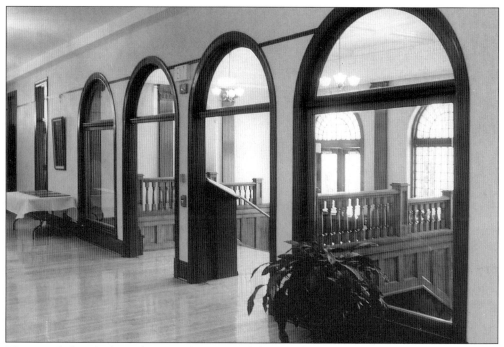

The rounded arched windows in the entry of the Heyde Center mirror those on the brick exterior of this historic building. The Notre Dame complex, including the Heyde Center, located on Catholic Hill overlooking the Chippewa Valley, was listed on the National Register of Historic Places in 1983. (Courtesy of Heyde Center for the Arts.)

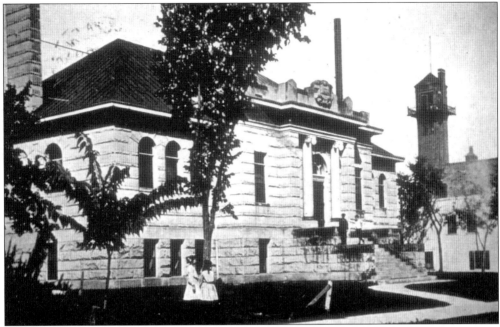

In the fall of 1910, Leslie Willson requested a personal interview with Andrew Carnegie to discuss funding for a public library in Chippewa Falls. Carnegie eventually agreed to give the city $20,000 for the beautiful stone structure of Romanesque architecture, which served the city and surrounding districts until 1969. (Courtesy of Delores Beaudette.)

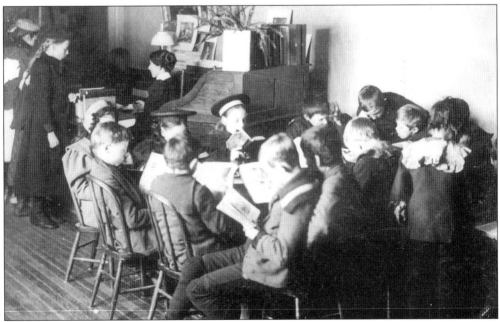

The children's' reading program has always been part of the library's mission. Through the generosity of several social charities, the children's room of the library was furnished and maintained. During World War I, the library, planning to send shipments of books to soldiers, asked residents to donate books with "snappy titles." (Courtesy of Delores Beaudette.)

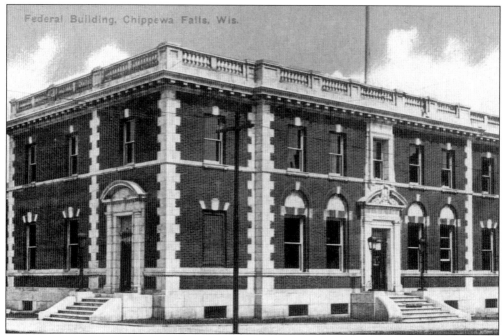

The United States Post Office and Federal Building, costing $90,000, was built in 1910, of brick and stone in the prevailing Neo-classic style. It is the only turn-of-the-century governmental public building remaining in Chippewa Falls that has maintained its original architectural form. (Courtesy of CCHS.)

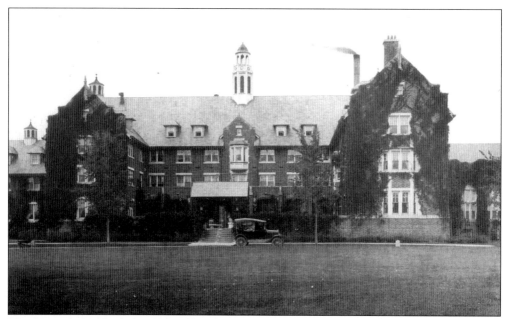

The Hannah M. Rutledge Home for the Aged, constructed between 1910 and 1913, is an exceptional example of Elizabethan architecture. Edward Rutledge donated funds for the construction as well as for an endowment in memory of his wife, "for the purpose of furnishing and maintaining a home for the worthy poor." (Courtesy of CCHS.)

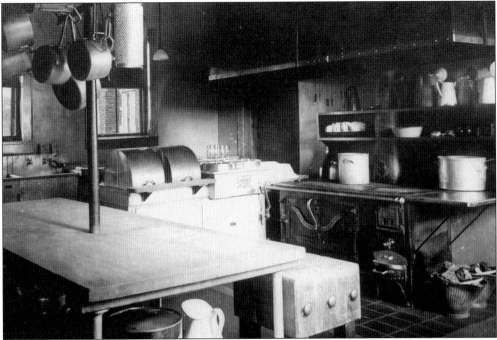

The kitchen of the Rutledge Home provided meals three times a day for as many as 94 residents. (Courtesy of Rutledge Home.)

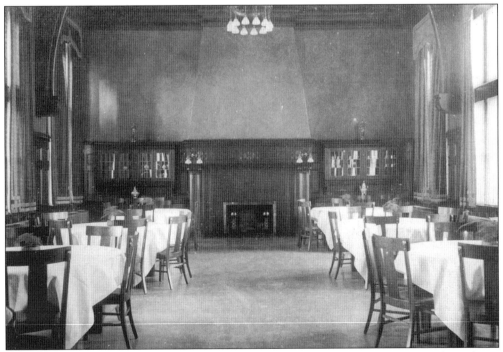

The dining room of the Rutledge Home featured white tablecloths and fresh flowers and was always decorated for the holidays. It is an example of the architecture designed for the purpose of social welfare, a concept of nursing home care well ahead of its time. (Courtesy of Rutledge Home.)

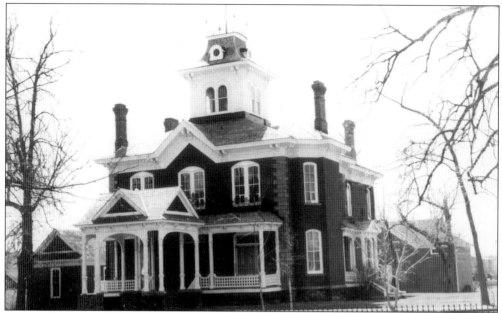

The Cook-Rutledge Mansion is the most elaborate representative of the Victorian Italianate style in Chippewa Falls. Built c. 1873 by prominent local and state politician James Bingham, it later became the home of wealthy lumberman and benefactor, Edward Rutledge, and his wife, Hannah. The last private owner, Mabel Cook, sold the home to the Chippewa County Historical Society. The mansion was placed on the National Register of Historic Places in 1974. (Courtesy of CCHS.)

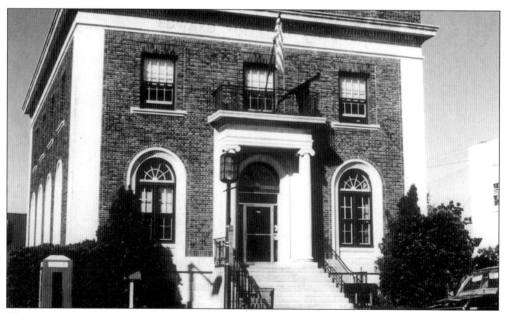

The Edward Rutledge Charities Foundation, administered by a corporation in accordance with his will, is housed in the Neo-classical Revival-styled building constructed in 1917. The foundation was established with a $1,000,000 donation from Edward Rutledge, and the foundation continues to donate to worthy causes today. (Courtesy of CCHS.)

Three
CHIPPEWA FALLS
IN THE GREAT WAR

Many Civil War veterans were still living when the United States entered the Great War in 1917. The sons of German, Norwegian, Italian, Irish, and Polish immigrants, ingrained with patriotism, joined the fight. The Louis Altman Band, dressed in snappy uniforms, was a popular musical attraction at many social gatherings in the Chippewa Valley in the early 1900s. The band was organized as the Fourth Wisconsin Infantry Band of the 32nd Division, whose duty it was to give concerts to the various units stationed in France and to entertain the sick and wounded soldiers. John M. Stickney was the first of 28 soldiers from Chippewa Falls to be killed in service. Sergeant Roy Holtz, riding a Harley-Davidson, was the first American on German soil after the Armistice was signed. The Louis Altman Band was the first unit to return to Chippewa Falls in 1919.

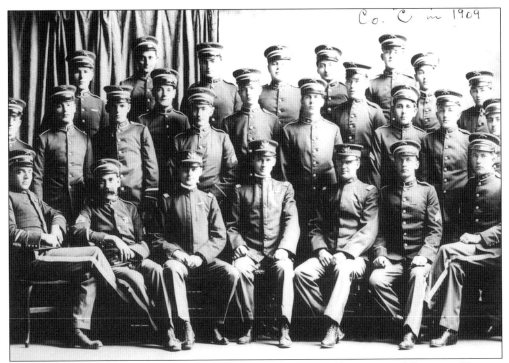

Company "C" sat for a formal picture in 1909, eight years before many of them would go to Europe to fight in the Great War, World War I. (Courtesy of CCHS.)

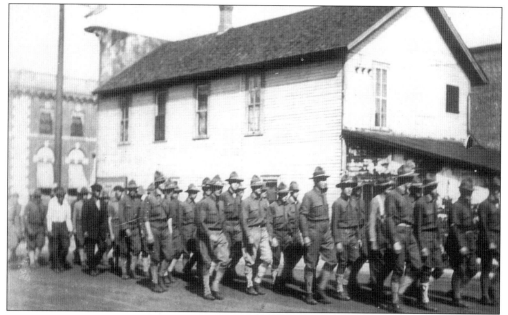

The United States declared war on Germany April 6, 1917, and a month later, the men of Company "C" went through their drill work on Columbia Street. The post office, visible in the background, processed thousands of letters from Chippewa Falls' families to their sons in the Great War. (Courtesy of CCHS.)

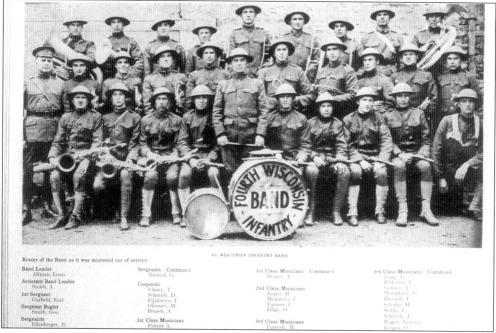

4th WISCONSIN INFANTRY BAND

Roster of the Band as it was mustered out of service:

Band Leader	Sergeants—Continued	1st Class Musicians—Continued	3rd Class Musicians—Continued
Altman, Louis	Birdsell, G.	Brager, A.	Long, A.
Assistant Band Leader	Corporals	2nd Class Musicians	Peterson, I.
Smith, A.	Cleary, T.	Jasper, H.	Gateen, A.
1st Sergeant	Schmidt, D.	Motarski, J.	Humphrey, G.
Garfield, Earl	Fijalwicz, J.	Turnow, C.	Duvnell, T.
Sergeant Bugler	Oksenee, M.	Zillgy, O.	Schultz, M.
Smith, Geo.	Brusen, A.		Stehle, J.
Sergeants	1st Class Musicians	3rd Class Musicians	Schleick, J.
Ellenberger, B.	Palmer, A.	Turerek, M.	Hagen, Norman
			Borgen, O.

Thousands attended the opening day of Irvine Park on May 17, 1917, and a concert given by the Louis Altman Band. More patriotism than in the past was displayed when the "Star Spangled Banner" was rendered. The Louis Altman Band became the Fourth Wisconsin Infantry Band, part of the 32nd Division. (Courtesy of Evalyn Frasch.)

The Louis Altman Band was the first unit to come home to Chippewa Falls after the Armistice. "Somewhere in France," Louis Altman visited his hometown friend Robert Wiley, a captain in the 32nd Division, who declared the band was one of the best bands in the unit. The band had entertained French residents with the Marseilles and played for the funeral of an American soldier. (Courtesy of CCHS.)

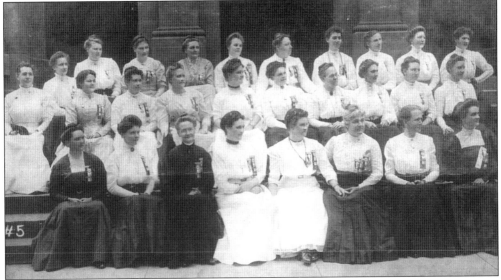

When the service star in honor of a son had turned to gold, the Gold Star Mothers received the poignant message: "Deeply regret to inform you that your son is officially reported as killed in action." (Courtesy of CCHS.)

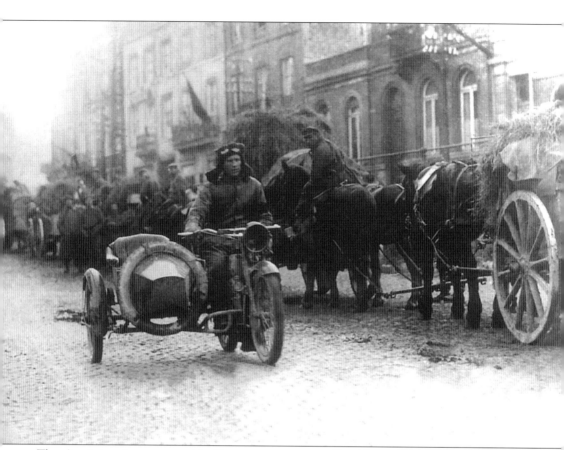

The Armistice Agreement with Germany went into effect November 11, 1918. The 32nd Division was assigned a sector to the north and east of Koblenz, and started moving immediately following cessation of fighting. On November 21, 1918, as a member of the division, Sergeant Roy Holtz, riding a Harley-Davidson motorcycle, became the first American to enter Germany after the Armistice. Several times he and his companion, who rode in the sidecar, were held up behind German lines. The above photo was taken on the streets of Spa, the great German headquarters, and it shows Sgt. Holtz on his motorcycle beside a German wagon train. The Germans were detaining his companion at the time. Sergeant Holtz could speak German fluently and was always able to gain freedom for himself. He returned to his hometown of Chippewa Falls on August 3, 1919. (Courtesy of CCHS.)

Four

Taming the Waters?



From a spring that forms Chippewa Lake deep in the Chequamegon National Forest, the Chippewa River drops 500 feet to the Falls. The clear, rapid river that entranced William Irvine in 1865 has unleashed its fury on Chippewa Falls many times. Nevertheless, lumbermen relied on the river to float logs that were cut upstream, down to a sawmill. The Chippewa Falls community relied on the river for transportation by ferries and steamboats. During the Civil War, recruits left from the ferryboat landing near Duncan Creek, traveling downriver to far away battlefields. However, lumbering interests prevailed, and dams were built to control the flow of logs downstream. By 1882, there were about 30 dams on the Chippewa River and its tributaries above Holcombe, which were designed to sluice logs or to hold water to create a flood on which to float the logs. When the logging era ended and the river was free of logjams, larger and more powerful dams were built across the Chippewa River to harness its energy for hydroelectric power. Even so, the dams have not been able to completely control the powerful flow of the Chippewa River.

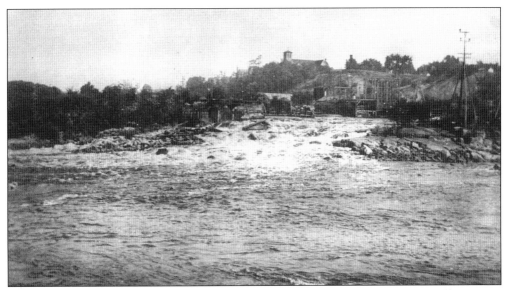

The Falls on the Chippewa River defined the area geographically and historically. Native Americans camped along the banks long before Jean Brunet paddled a canoe up the river, where he encountered the roaring water tumbling over granite rocks. The Falls, located just above the junction of Duncan Creek and the Chippewa River, became the focal point for the young city of Chippewa Falls. (Courtesy of CCHS.)

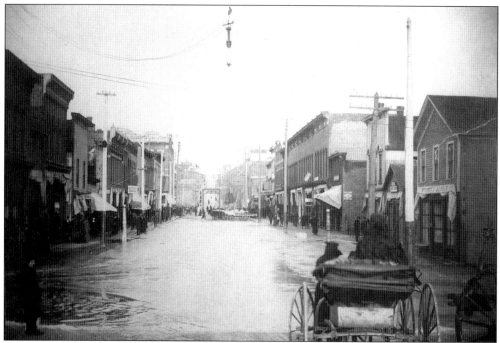

Piers, dams, and booms tried to harness the wild torrents of the creeks and rivers, but often failed. Spring Street merchants experienced many floods similar to the Flood of 1897. (Courtesy of Rutledge Home.)

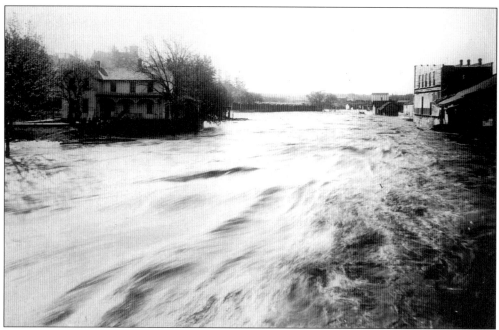

Duncan Creek, named after J.H. Duncan who built a small sawmill where the Glen Lock Dam now stands, flooded its banks in 1900, and carried off several bridges in the process. (Courtesy of CCHS.)

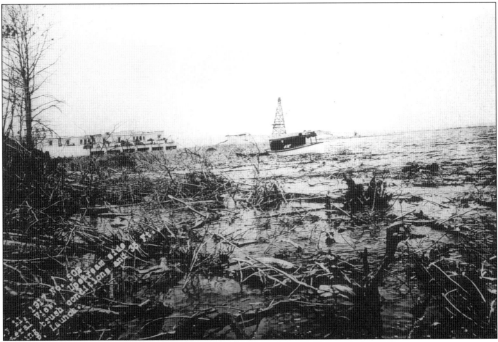

In the movie *Titanic*, lead character Jack Dawson said he grew up near Chippewa Falls and had gone ice fishing with his father on Lake Wissota. However, when the *Titanic* sank in 1912, Lake Wissota had not yet been created. This excursion boat was having difficulty maneuvering through the debris as the lake was forming in 1917. (Courtesy of CCHS.)

The Wissota Dam project, begun in 1915 by the Wisconsin-Minnesota Power and Light Company, was so extensive that it required a small town with houses, dining hall, hospital, and a school for the children. (Courtesy of Robert Crane.)

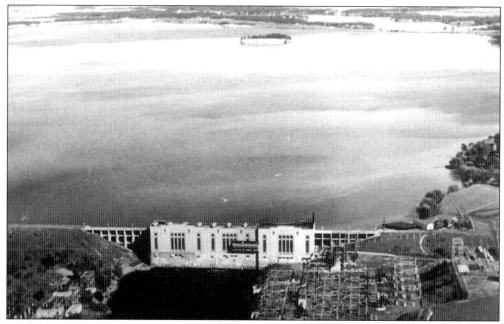

Completed in 1918, the Wissota Hydro Plant was the world's largest at the time. With six generators and 13 spillway gates, the Wissota Dam impounds 6,300 acres of water, which creates 56 miles of shoreline. The Hydro Plant became the chief source of power for the city after 1918. (Courtesy of Ronald Lea.)

The Chippewa Falls Main Street program capitalized on the city's newfound fame in the movie *Titanic* by sponsoring a Jack Dawson look-alike contest. The winner was Andy Heinlein of Oconomowoc, Wisconsin. (Courtesy of CFMS.)

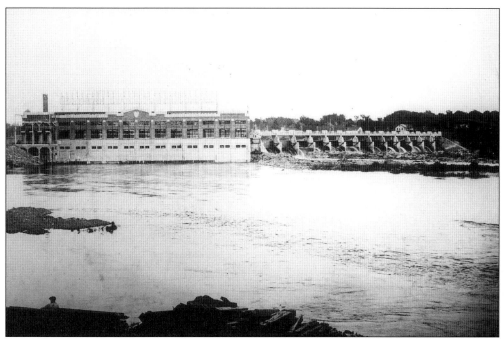

The Chippewa Falls Hydro Plant was completed in 1928, and has six generators, 13 spillway gates, and impounds 265 acres of water. It is controlled at the Wissota Dam site. (Courtesy of CCHS.)

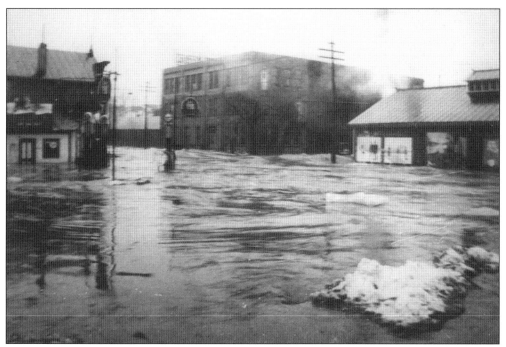

Even the more sophisticated series of dams on the Chippewa River could not always control the rising waters. Duncan Creek roared out of its banks in 1934, flooding the area of Elm and Jefferson Streets near the site of the Woolen Mill. (Courtesy of Rutledge Home.)

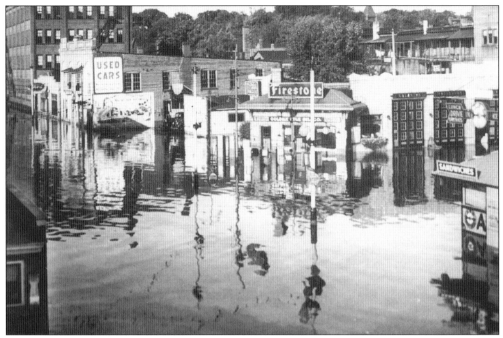

The 1941 Labor Day flood inundated downtown Chippewa Falls. As a consequence of the excessive rainfall in northwestern Wisconsin, the floodwaters caused the north end of the railroad bridge to sink 5 inches after two trains had crossed. The Labor Day flood was 5 feet shy of the all-time mark set in 1884. (Courtesy of Ronald Lea.)

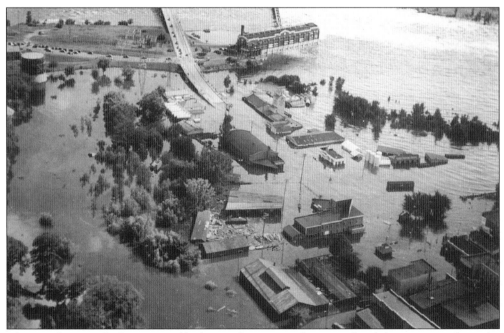

The aerial view of Chippewa Falls during the 1941 Labor Day flood demonstrates how the Chippewa River, fed by overflowing Duncan Creek, climbed up its banks and spread over the downtown area of Chippewa Falls. (Courtesy of Ronald Lea.)

Five

UPBUILDING THE
BUSINESS COMMUNITY

Historically, Chippewa Falls has been the beneficiary of farsighted individuals who understood the importance of creating a strong and supportive industrial base for the community as a whole. In 1902, the Progressive League members, anticipating the decline of businesses associated with the waning lumber era, determined that a partnership between industry and the community was integral to what they termed "the upbuilding" of the community. It extolled the facilities for communication with the "outer world," including 32 passenger trains daily and three railroad lines, excellent mail service, a long distance telephone connection, and rich agricultural products. Its promotional efforts were successful, and Chippewa Falls became known as the "City that Does Things."

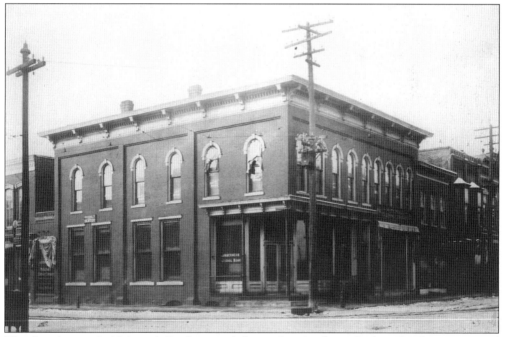

The Lumberman's National Bank provided another banking facility for businesses and residents. Founded in 1887, the bank's original officers were Alexander McDonell, President; Edward Rutledge, Vice-President; and Directors Frederick Weyerhaeuser, William Irvine, and Edward Rutledge. (Courtesy of CCHS.)

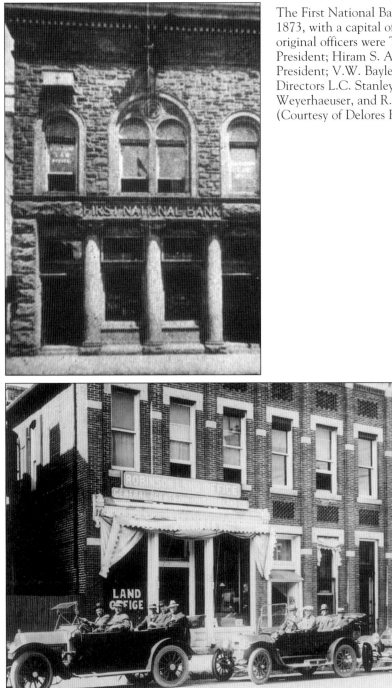

The First National Bank was organized in 1873, with a capital of $75,000. The original officers were Thaddeus Halbert, President; Hiram S. Allen, Vice-President; V.W. Bayless, cashier; and Directors L.C. Stanley, Frederick Weyerhaeuser, and R.D. Marshall. (Courtesy of Delores Beaudette.)

The Northwestern Bank was chartered in 1904, with a capital of $80,000. S.C.F. Cobban was president, Thomas Kelly was vice-president, and P.T. Favell was cashier. The directors were Cobban, Favell, Kelly, Poznanski, Bartlett, McKinnon, W.M. Bowe, and H.B. Coleman. Constructed with cream brick in the Neo-classic style, it represented progress and stability. (Courtesy of CCHS.)

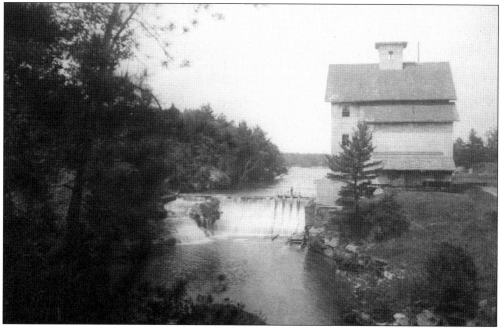

The Star Flour Mill, erected in 1879 on Duncan Creek by Hector McRae, had the capacity to manufacture 100 barrels of flour every 24 hours. (Courtesy of Delores Beaudette.)

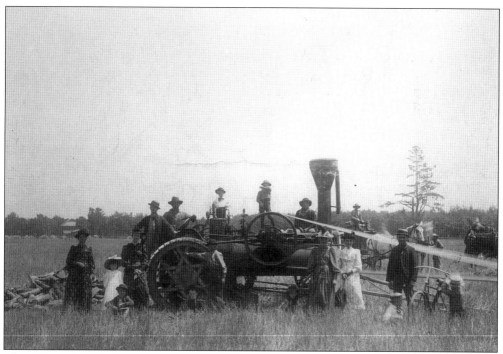

The prairie above the rivers provided fertile farmland for those willing to clear the stumps from the land. The Jacob Kaiser farm, in 1892, was located at the west end of Wheaton Street. Local mills and Leinenkugel Brewery used almost all the grain produced on the farms. (Courtesy of Rutledge Home.)

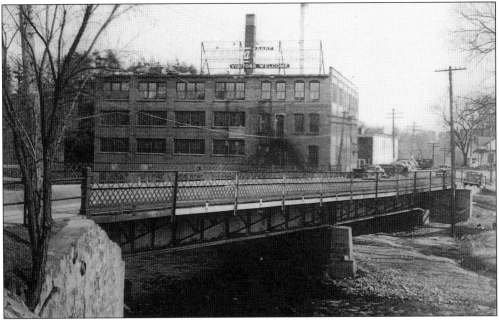

Woolen manufacturing became a staple of Chippewa Falls' industry during the late 19th and early 20th centuries. Erected along Duncan Creek in 1884 by Hector McRae, the Chippewa Woolen Mill, at its peak, employed about 50 workers and produced mackinaws, wool battings, auto robes, and wool clothing, which were marketed nationally as "Made in Chippewa." (Courtesy of CCHS.)

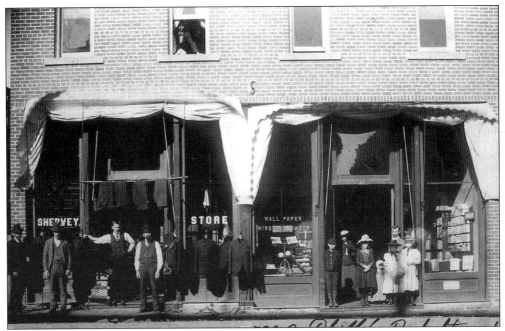

In 1893, the Shervey Store, a general merchandise store, and the adjoining M.A. Phillips, a bookstore and retail enterprise on Spring Street, were representative of the stores and shops designed to meet the needs of a growing community. (Courtesy of Rutledge Home.)

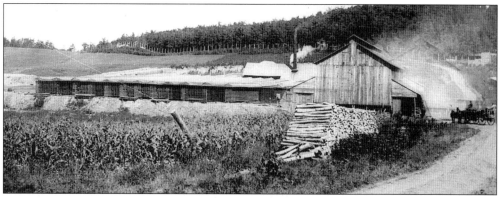

J.B. Theriault came to Chippewa Falls to work in the lumber camps and sawmills. About 1877, he went into the brick manufacturing business, which he pursued for 23 years. His office was located at 301 Bridge Street, and the brick plant was 2 miles west of the city in Tilden. (Courtesy of CCHS.)

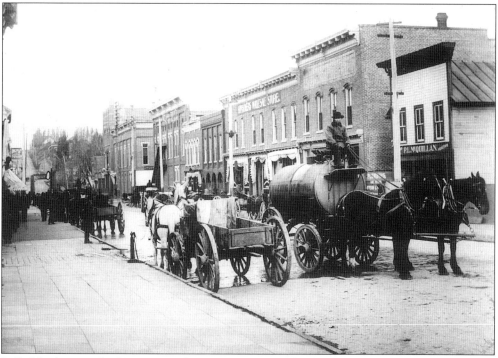

Pulled by horses, the Hoenig Hardware wagon passed by the McQuillian Plumbing store on Central Street at the turn of the century. Established in 1878, the hardware store featured household crockery, furniture, and undertaking goods. (Courtesy of Mary Anderson.)

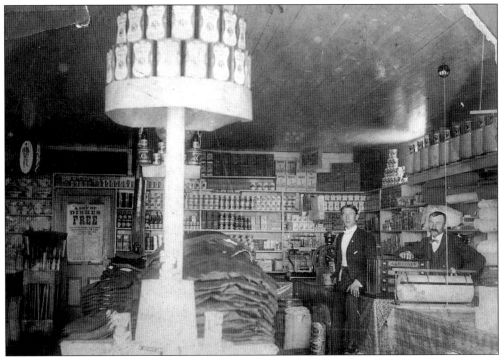

The interior of E. Poznanski Company in 1907 contained "everything from a pin to sealskin," and described itself as the "handsomest dry goods house in northern Wisconsin." (Courtesy of CCHS.)

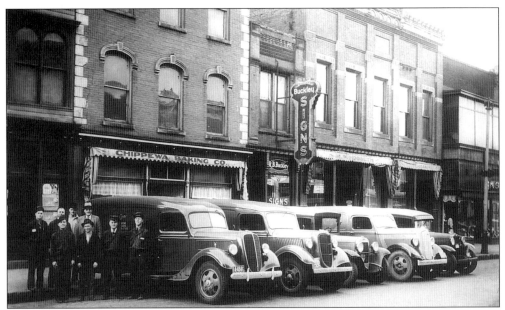

The Chippewa Steam Bakery, established in 1904 by C.O. Lea, was in business for 57 years before closing in 1961. The business began with a horse-drawn delivery wagon, but in 1914, a new truck was purchased. As the business expanded, so did its fleet of delivery wagons. (Courtesy of Ronald Lea.)

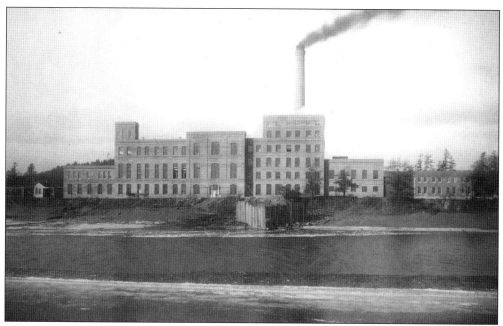

Securing the Sugar Beet Factory in 1902 was a great victory for the Progressive League. It had a daily capacity of 800 tons of beets, paying over $3,000,000 to the farmers annually and over $50,000 for labor. (Courtesy of Rutledge Home.)

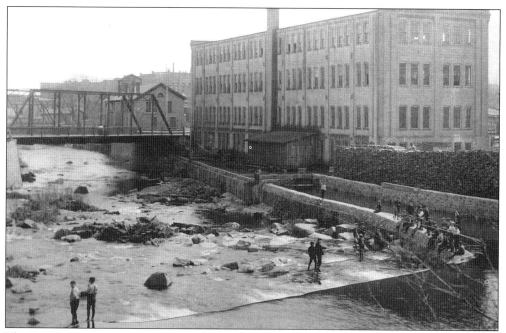

The C. Gotzian Company took over the Harshman plant on April 1, 1904. Also on that date, Bernard Mason, with help from his father, August, and in partnership with August Kuhrasch, purchased the Independent Hand Made Shoe Company, marking the beginning of Mason Shoe Manufacturing Company, which, five generations later, is still producing Mason Shoes and is the largest shoe catalogue company in the world. (Courtesy of CCHS.)

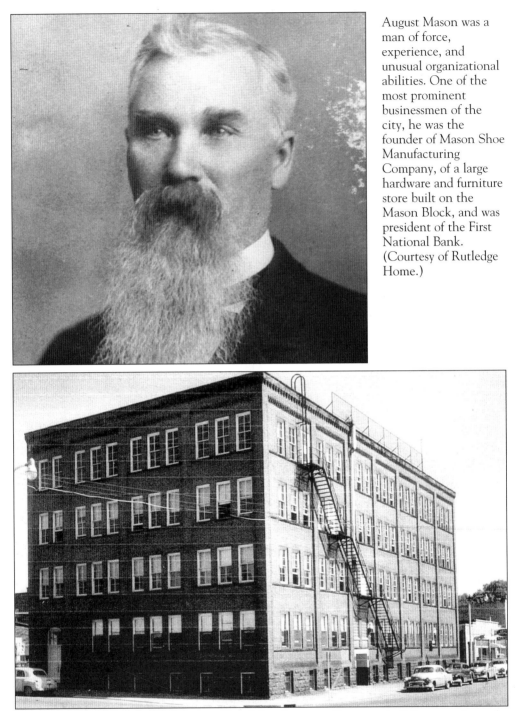

August Mason was a man of force, experience, and unusual organizational abilities. One of the most prominent businessmen of the city, he was the founder of Mason Shoe Manufacturing Company, of a large hardware and furniture store built on the Mason Block, and was president of the First National Bank. (Courtesy of Rutledge Home.)

Built in 1910, the four-story Chippewa Shoe Manufacturing Company building once housed a plant employing 175 people, mostly women, who produced 1,200 pairs of shoes daily. It is the only known architectural representative of the early shoe manufacturing industry remaining in the city. The company ceased business in 1985. The original building was rehabilitated in 1995, and is now the Chippewa Shoe Factory Apartments. (Courtesy of CCHS.)

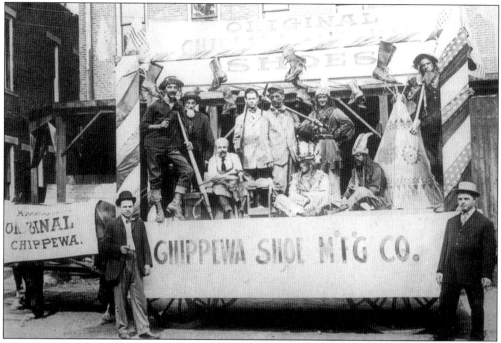

John Piotrowski came to Chippewa Falls to build a factory and produce strictly hand-made goods. Financed by J.B. Kehl, L.M. Newman, and Leslie Willson, the Chippewa Shoe Company began operations in March 1901. A parade provided an excellent opportunity to advertise the company's quality leather products. (Courtesy of CCHS.)

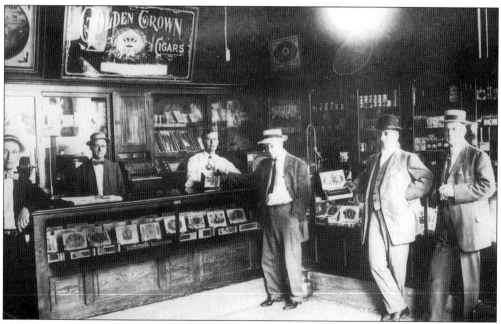

The Hebert Brothers Cigar Store, with its "Dark Raven" trademark, was one of four cigar manufacturers in Chippewa Falls in 1910. Their leading 10¢ cigar was the H.B. Heinrich, and the best 5¢ cigars were the Red Axe and the War President. (Courtesy of CCHS.)

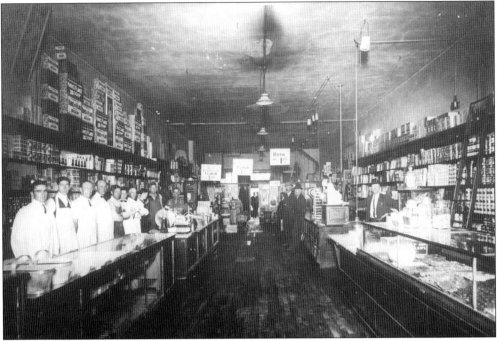

The Farmers Produce Company Grocery Store, one of the largest enterprises in the city in 1915, displayed the latest fashions in one department while in another area bananas were ripened for sale. (Courtesy of Rutledge Home.)

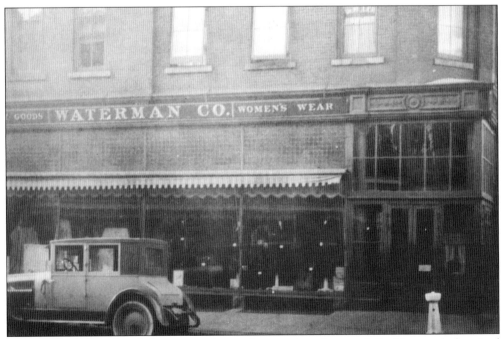

The Waterman Dry Goods Store was a dry goods emporium that specialized in popularly priced dry goods and ladies clothing. Waterman's had a long retail history. Today the Union Block building across the street houses a similar business, Foreign Five. (Courtesy of CCHS.)

The Chippewa Glove Factory at 10 West Spring opened in 1905, bringing more diversification and employment opportunities to the city. In 1940, the Glove Factory was awarded a contract by the United States War Department for the manufacture of 90,000 pairs of heavy leather gloves. The contract price was $94,000. (Courtesy of CCHS.)

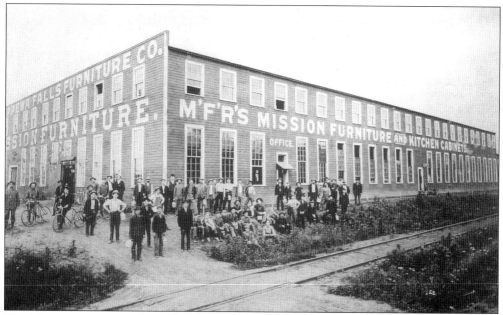

The Chippewa Furniture Manufacturing Company was secured by the Progressive League in 1905. It became well known for its mission-style furniture and kitchen cabinets. (Courtesy of CCHS.)

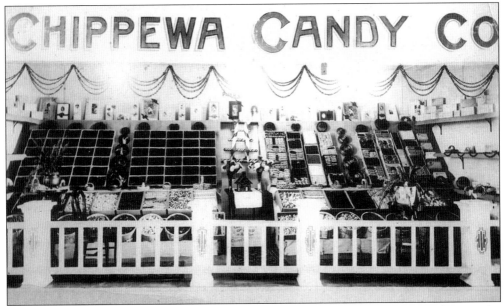

Chippewa Candy Company factory was literally "Made in Chippewa," since everything in the factory was purchased or made in Chippewa Falls. The display of candy included chocolate creams, chocolate bars, penny candy, and all kinds of packaged candy. (Courtesy of CCHS.)

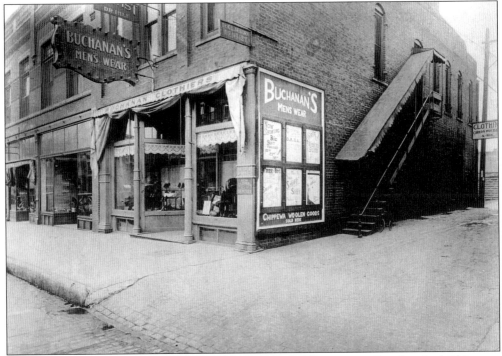

In 1924, Buchanan Clothiers, in the 200 block of Bridge Street, proudly advertised Chippewa Woolens on the side of its store. The store closed in 1941. (Courtesy of CCHS.)

Tschopp Durch Camastral was organized in 1917, when three friends began to manufacture cabinetry and coaster wagons from lumber milled on the Durch farm. The company later manufactured panelized houses called "Chippewa Homes," and built several schools, churches, and commercial buildings in Chippewa Falls. It is still in business today. (Courtesy of Tschopp Durch Camastral.)

Chippewa Falls is home to W.S. Darley Pump Division and Fire Engine Assembly operations. William Darley founded the company in 1908. The company originated in Chicago, but in the 1920s Mr. Darley, along with Pete Yates, an accomplished pump engineer, formulated plans for a factory that Mr. Yates, a native of this area, insisted be located in Chippewa Falls. (Courtesy of W.S. Darley & Co.)

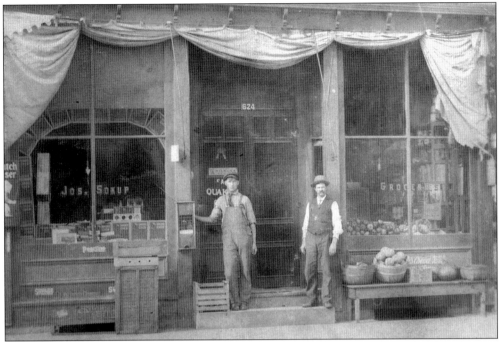

Joseph Sokup, who made deliveries with a horse and wagon, opened Sokup's Market in 1894. His son, Peter, ran the business for nearly 50 years before retiring in 1963. (Courtesy of the Sokup family.)

John Sokup has been associated with the grocery business since he was a youngster. His son, Peter, is part of the fourth generation to carry on business over the meat counter and make deliveries to area homes and businesses. (Courtesy of the Sokup family.)

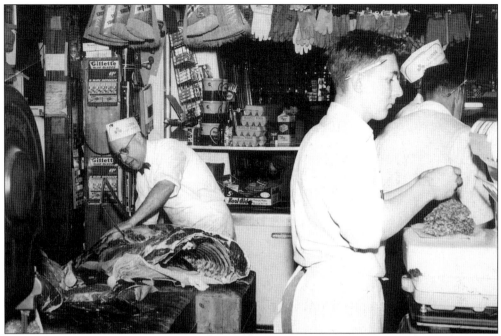

Gutknecht's Market opened during the Depression in 1930, and it thrived as store personnel put together individual orders at the counter for patrons. Behind the meat counter, Robert Gutknecht cut meat while his son, David, weighed an order. (Courtesy of the Gutknecht family.)

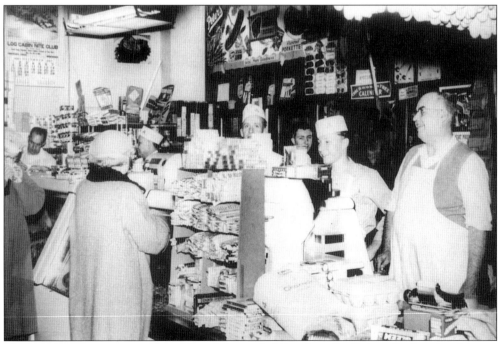

The popular meat counter, where (from left to right) Ray Loiselle, Robert Gutknecht, Gilmore Gutknecht, David Gutknecht, Robert Gutknecht, and Bernard Gutknecht served customers, is still an institution at this fourth generation family business. (Courtesy of the Gutknecht family.)

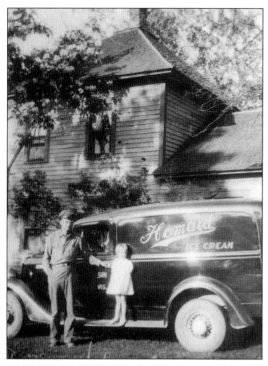

Homaid Ice Cream was created by A.J. Olson in 1923. Since moving to Chippewa Falls in 1944, Olson's Creamland Dairy has become, literally, a Chippewa Falls landmark with its larger than life ice cream cone outside the front door. (Courtesy of the Olson family.)

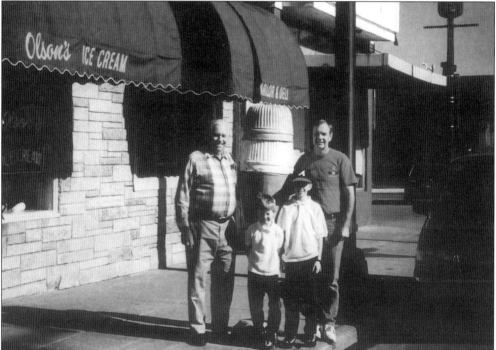

Howard Olson, on the left, makes fresh ice cream daily, in 22 flavors, from the same recipe his father created. His son, David, far right, who oversees the deli operation, is pictured with his two sons John and Patrick, perhaps the next generation to carry on the Homaid tradition. (Courtesy of the Olson family.)

Six

BOATS, STAGES, TRAINS, AND PLANES

Hundreds of miles of trails created by Native Americans pursuing seasonal activities or engaging in trade with each other criss-crossed Wisconsin. Soon fur traders, missionaries, and lumberman were using the trail systems and water routes to hunt, trade, proselytize, and to reach vast white pine forests. The booming lumber era required faster ways of moving people and goods. Lumbermen who rafted down the Chippewa River were soon able to take one of the stage lines back upstream. Steamboats and keelboats ferried people and supplies up and downstream. Stage lines, which closely followed Native American trails, gave way to railroads that carried goods, lumber, and people faster and farther. Interurban trains between Chippewa Falls and Eau Claire ran several times a day, before buses took over those routes. And then there were planes, including one manufactured in Chippewa Falls.

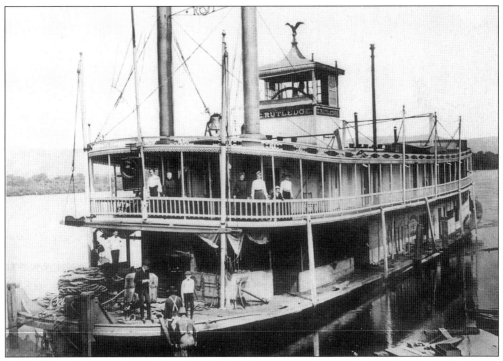

A paddlewheel steamboat called the *E. Rutledge* was used to tow log rafts on the Chippewa River. As the lumber industry prospered, it became more difficult for the steamboat pilots to navigate the river due to the stray logs. (Courtesy of Edward Rutledge Charity.)

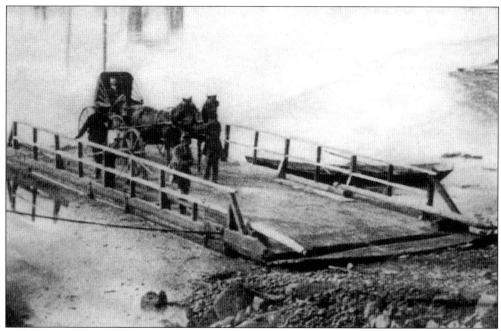

In the 1850s, the ferry ran across the river from Frenchtown to Chippewa Falls. The charge was 50¢ per team, 25¢ for adults, and children free. In 1868, the first bridge was built across the river near the mill. The bridge was burned down on July 7, 1870. The owner of the ferry was suspected of setting the fire, but he was never found guilty. (Courtesy of CCHS.)

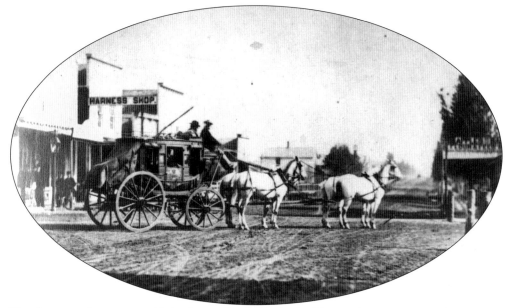

The first stage line was established in 1850, by the H.S. Allen and Company Lumber Mill in order to return the men who rafted lumber to Lake Pepin back to Chippewa Falls. In the late 1860s, the local depot was at the corner of Bridge and West Spring Street. In June 1870, the stage line to Sparta was opened. There was much excitement when a new Concord stage, drawn by four matching white horses, left the Rousseau tavern in Frenchtown. (Courtesy of CVM.)

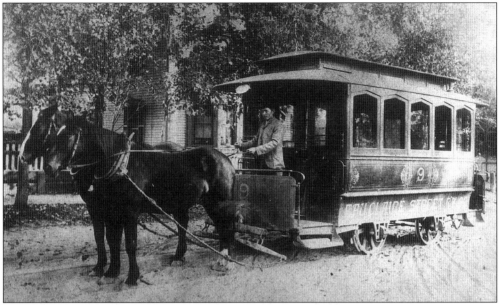

The first streetcars in the Chippewa Valley were horse-drawn. Native Americans were often hired as drivers because they were more skilled at handling the horses. (Courtesy of Charles Schaaf.)

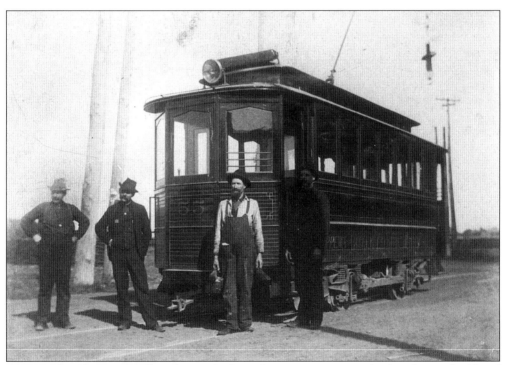

In 1897, the Chippewa Valley Electric Railway Company was granted a franchise to build and operate an electric line in Chippewa Falls as well as an interurban service between Chippewa Falls and Eau Claire. Northern States Power Company of Wisconsin, now Xcel Energy, later operated the electric railway. (Courtesy of Charles Schaaf.)

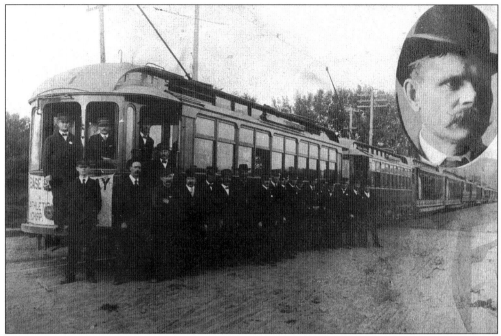

The interurban railway that ran from Eau Claire and passed by Lake Hallie and Electric Park continued directly into downtown Chippewa Falls and on to Irvine Park. Being a motorman on the streetcar was hard work. They had to keep a constant watch for children, animals, and automobiles. (Courtesy of Charles Schaaf.)

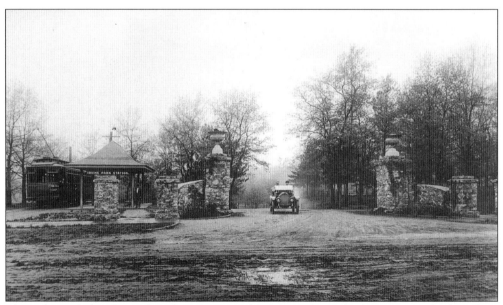

The railway shelter located at the entrance of Irvine Park was built in 1907. The line from Chippewa Falls to Eau Claire was almost 12.4 miles long and took approximately 45 minutes. The cars ran every hour, and the charge was 20¢ per passenger. The line was abandoned in 1926, largely due to the increasing popularity of the automobile and the Motorbus Company of Chippewa Falls. (Courtesy of CCHS.)

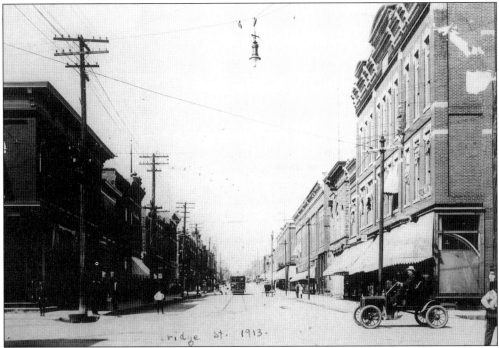

The first car in Chippewa Falls was a one-cylinder Cadillac bought by Robert Clark, Dr. Fred Cook, and George McCall. This photo was taken looking north on Bridge Street in 1913. Dr. Nussle is pictured driving another of Chippewa's first automobiles. (Courtesy of CCHS.)

McGuirie Livery was built in 1888. During the 1890s, the livery could accommodate 35 horses. It later became the location of the Ben Franklin Store. The stable windows were bricked in but are still visible on the west wall of the Ben Franklin building. Just before World War I, Mr. McGuirie bought several automobiles. (Courtesy of CCHS.)

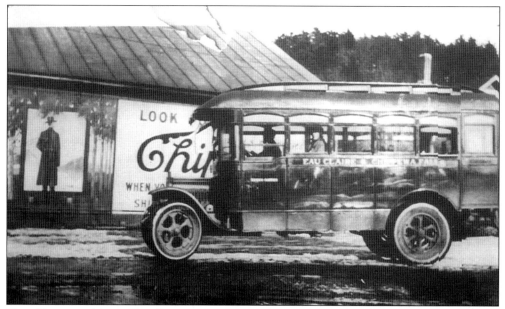

The Chippewa Motor Bus Company was started in 1920, under the ownership of several members of the Agnew and Willette families. It started with two buses, which ran every 30 minutes between Chippewa Falls and Eau Claire. The depot, opposite the Hotel Northern, was in a convenient location. In 1964, the company was purchased by Wisconsin-Michigan Coaches Inc. (Courtesy of Gail Willi.)

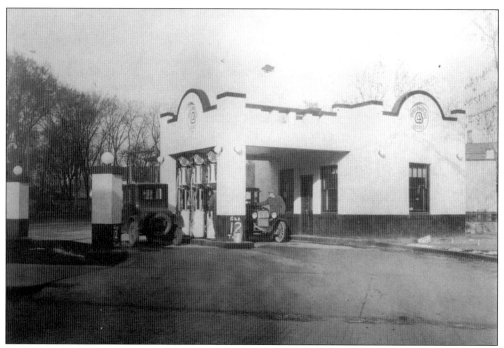

Cities Service Oils station was built shortly after World War I at 623 North Bridge Street, across from Sokup's Market. The owner was Alvin Rasmus. This is now the site of the Indianhead Plaza Office Building. (Courtesy of CCHS.)

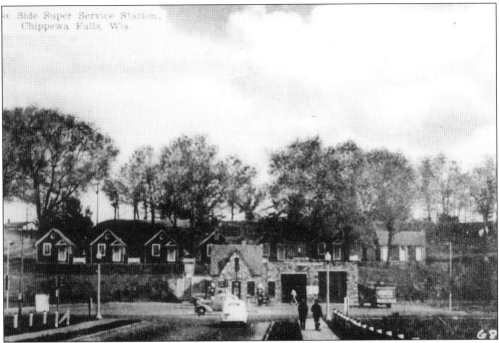

Prior to 1854, roads were merely trails, but by 1888, all the major routes into and out of Chippewa Falls were in place. However, by 1924, only about 5 miles of the streets in the city were paved in brick or concrete. With the improvement in the road system, service stations, many with overnight accommodations, became common fixtures along the road connecting Chippewa Falls with surrounding communities. The Yellowstone Trail, a transcontinental road built in the early 1900s, carried motorists from Plymouth Rock past the Southside Service Station to Puget Sound. (Courtesy of CCHS.)

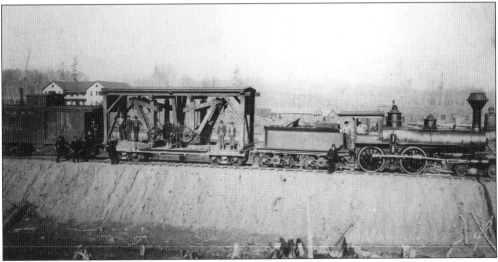

The Chippewa Falls and Northern, a construction subsidiary of the Omaha Road, built a railway line from Chippewa Falls north to Bloomer in 1881. This company also built the first railroad bridge in Chippewa Falls. It was the eastern most of four railroad bridges that were built in Chippewa Falls. (Courtesy of Rutledge Home.)

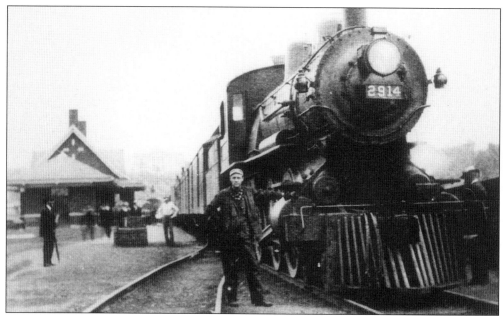

The first railroad built into Chippewa Falls was the Chippewa Falls and Western. The company was organized in 1873, and its president was Thaddeus Pound. The 10.25-mile railroad with one locomotive and one coach connected the south side of Chippewa Falls to Eau Claire. It later came under the management of the Wisconsin Central. This is the depot on River Street between Bay and Island Streets. (Courtesy of CCHS.)

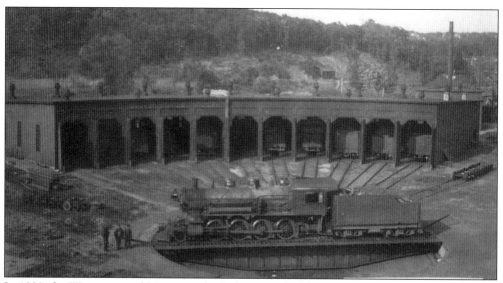

In 1882, the Wisconsin and Minnesota built the second of the Chippewa Railroad bridges. It was about one block upstream from the present Highway 124 bridge. From there, the tracks went along River Street and extended to the west side of Chippewa Falls, where the Irvine Yard was established. Chippewa Falls was a crew change point, and cabooses were switched so that a caboose stayed with the conductor. The caboose track behind the yard office was extended to become the Amoco Plastics, now Pactiv, plant track. Train crews stayed at the Beanery Hotel next door, now known as the Irvine Bar. The roundhouse was demolished in 1997. (Courtesy of CCHS.)

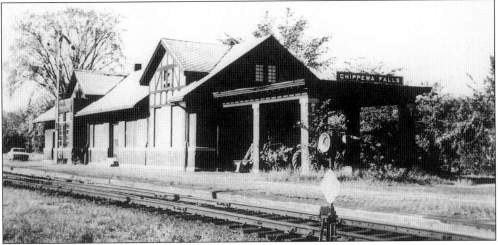

By the late 19th century, three railroads and as many as 32 passenger trains a day served Chippewa Falls. This photo of the Chicago Northwestern Depot was taken in 1954. The last passenger train into this depot was in 1961, and the last passenger train into Chippewa Falls was on the Soo Line in 1963. (Courtesy of CCHS.)

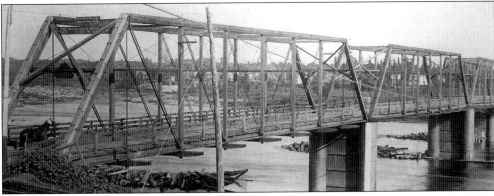

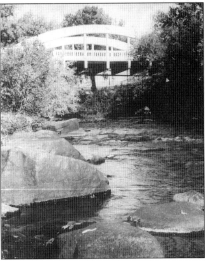

The old wooden bridge crossed the river from Main Street on the south to Taylor Street on the north. Beginning in 1898, the electric trolleys used this bridge. By 1900, due to the extra wear caused by the streetcars, the bridge needed immediate repairs. It was believed that within a few years of the repairs, the bridge would need to be completely overhauled or a new bridge would need to be built. (Courtesy of Rutledge Home.)

The Marsh Rainbow Arch Bridge was placed on the National Register of Historic Places in 1982. The bridge was built on East Spring Street in 1916, for approximately to $14,000. It is the only remaining example in Wisconsin of a patented reinforced concrete arch bridge. (Courtesy of CFMS.)

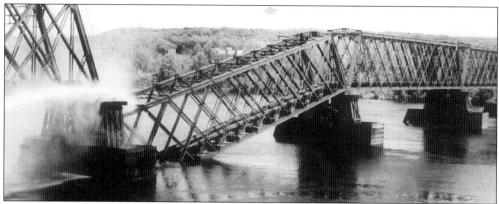

On July 20, 1993, an act of arson destroyed an entire span of the Chicago and Northwestern Railroad bridge. At the time of the fire, the bridge was nearly 100 years old. Around 1950, the Chicago and Northwestern Railroad purchased the line and the bridge from the old Omaha Railroad. (Courtesy of CCHS.)

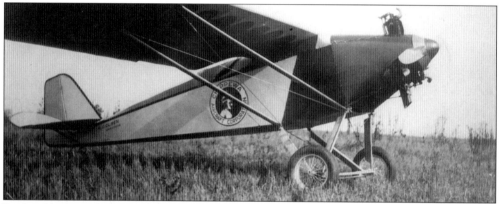

Reider Olsen was born in Norway and immigrated to Merrill, Wisconsin, in 1922. In 1928, he moved to Chippewa Falls and built this monoplane called the *Olsen Scout*. He used a Szekely 30 h.p. engine. The logo on the fuselage reads "Chippewa Aircraft Corporation." (Courtesy of CCHS.)

The Chippewa Civil Air Patrol Squadron was founded in May 1956. Hank Rosenbaum, one of the founders, is standing next to one of the squadron's first planes in this 1950s photo. (Courtesy of CCHS.)

Seven

CHURCHES AND SCHOOLS

Many of the cultural and artistic traditions of immigrants survived the transition from their former lives to their new ones in Chippewa Falls. Almost as if paying homage to that which they left behind, the first generation created churches, homes, and schools in the architectural styles of their homelands.

The first superintendent of schools in Chippewa County was James Taylor in 1854. Hired by Hiram Allen and Thomas Randall, the first teacher, Miss Mandane (Mary) Buzzell, who later became Mrs. James Taylor, instructed the students in a small wooden structure. By 1870, the school system consisted of a primary, two intermediate, and one high school. In 1881, at their own expense, the Catholic church on Notre Dame Hill took over the instruction of children of the Catholic faith, saving the city $4,000 a year.

The churches were clearly a product of ethnicity. Notre Dame, the "Mother Church," ministered to all Catholics, regularly preaching in English, German, and French. Eventually, St. Charles was established to serve the German-speaking Catholics while Holy Ghost, located in Frenchtown, served the French-speaking congregation. Protestant churches for Presbyterians, Methodists, Episcopalians, Baptists, Evangelicals, and Lutherans also revealed the influence of immigrant groups.

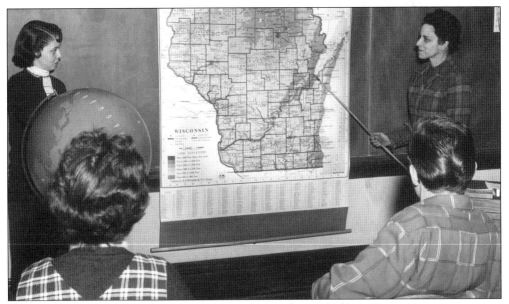

Cecilia Dranzfelder is teaching a Wisconsin History class in 1954.

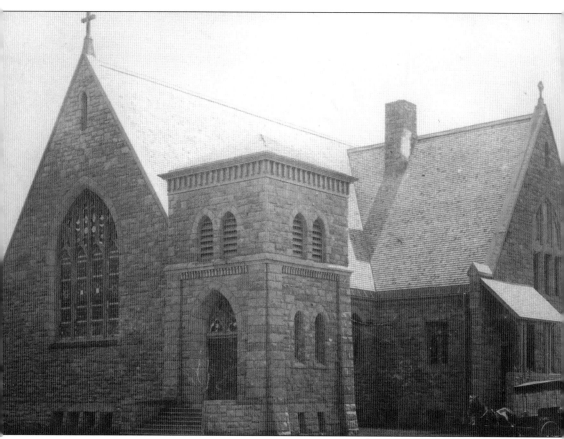

The present Christ Episcopal Church was built of substantial stone construction in 1897. The simple cut-stone surfaces with pointed arch windows and door is an example of simplified Gothic Revival architecture. The Protestant Episcopal Church was organized in April 1866. Old Badger, the horse, 25 years old in 1902, served faithfully for many years. (Courtesy of Christ Episcopal Church.)

The Presbyterian Church, the first Protestant church in Chippewa Falls, was organized in 1855. The present church, constructed with Menomonie brick in 1883 at 130 West Central, is the only extant representative of the 19th century Victorian Gothic church architecture in the city. Hiram S. Allen, Hector McRae, and John Kehl were early members of the congregation who listened to the Steere-Turner-Tracher organ installed in 1889. (Courtesy of CCHS.)

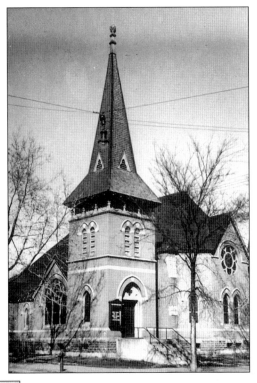

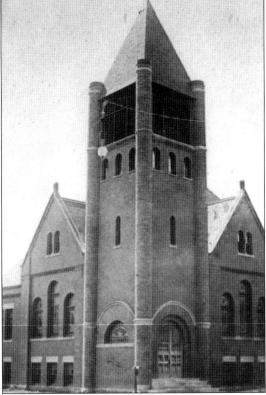

The Methodists organized in 1860, and constructed their first church in 1870. On the site of the old church in 1892, with Hiram S. Allen serving as local contractor, a Romanesque Revival-styled brick church was erected at 201 West Central. Upon its completion, Rosa Jenkins donated an electric organ, the first electric church organ in the city. (Courtesy of CCHS.)

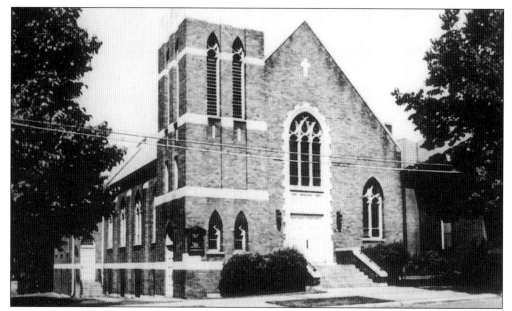

Zion Evangelical Church, now known as Zion United Methodist Church, was organized in 1867, by Germans who built their first church in Tilden. In 1885, the same denomination erected a church at 1102 Superior Street. The congregation replaced the original church in 1922, with this one built in the Gothic Revival style with plain brick walls and simple square towers. (Courtesy of CCHS.)

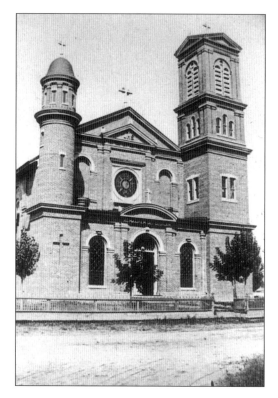

German Catholics, assisted by Father C.F.X. Goldsmith, formed a parish and built a Romanesque Revival-style church in 1884–85, at 812 Pearl Street. St. Charles Borromeo Catholic Church was dedicated in 1886, with Reverend Theodore Hegeman serving as its first pastor. (Courtesy of CCHS.)

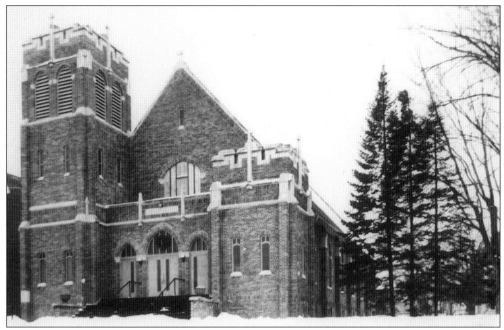

The original Holy Ghost Church was built in 1886 in Frenchtown, to serve the Catholics on the south side of the city. Replaced in 1927 by a Tudor Gothic-style church with square towers flanking the gable shaped facade, Holy Ghost sits at the top of the hill on the corner of Main and Greenville Streets. (Courtesy of CCHS.)

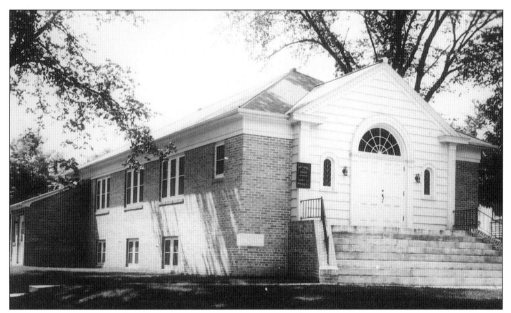

The First Church of Christ Scientist is the only extant church building based on Classical design in Chippewa Falls. The simple brick structure was constructed in 1941, for a congregation that had been organized in 1901. Services at the Church and Reading Room, where Mabel Cook was one of the first readers, were held every Wednesday and Sunday. (Courtesy of CCHS.)

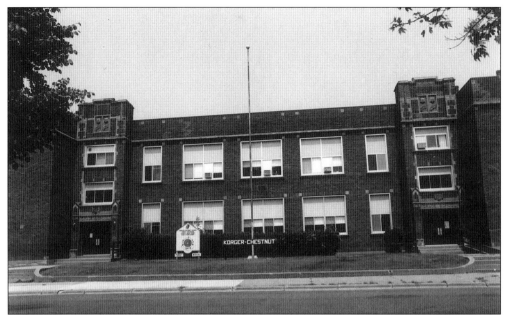

Chestnut Street School, erected in 1882, was known as the Stanley Hill School, the Olive Street School, and, when it was rebuilt in 1925, it was called Chestnut School. Gertrude Korger was honored for her tenure as principal when the school was renamed Korger-Chestnut School. (Courtesy of CFMS.)

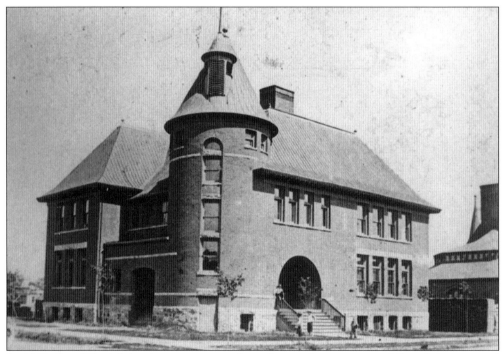

In 1868, First Ward School was constructed on the northeast corner of Grand Avenue and Beaver Street on what was known then as Catholic Hill. Rebuilt in 1887, and remodeled in 1925, it has a new life as the Chippewa Falls Area Senior Center. (Courtesy of CCHS.)

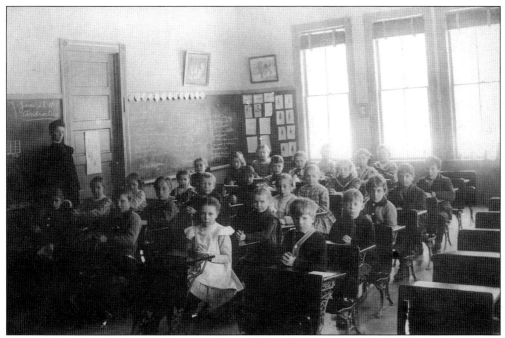

By 1870, First Ward School contained an elementary and intermediate department. Teacher Adelaide Nussle stands in a classroom at First Ward School on January 28, 1910. (Courtesy of CCHS.)

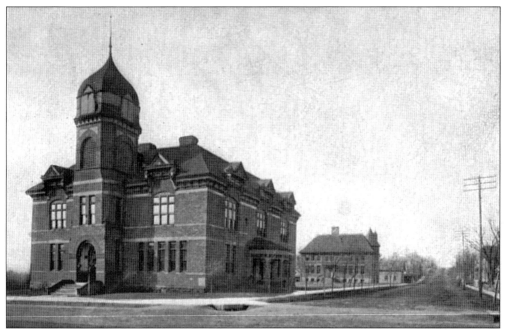

In 1858, a district schoolhouse was erected on Bay Street, and later a high school was constructed on the same site. Three times fires burned the school, and each time the school was rebuilt. In 1907, the building became the Chippewa Falls Junior High School. The smaller school in the background is Island Street School. (Courtesy of CCHS.)

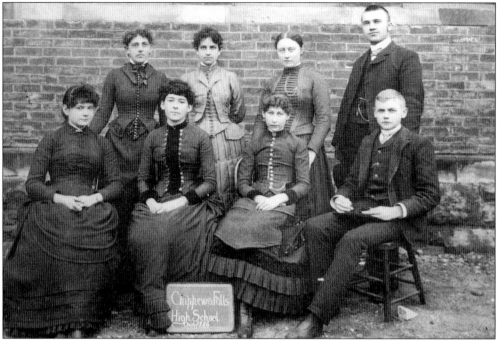

The Chippewa Falls High School Class of 1886 gathered for a formal graduation picture. Education was valued highly, especially by immigrant parents whose own education was interrupted by emigration. (Courtesy of Delores Beaudette.)

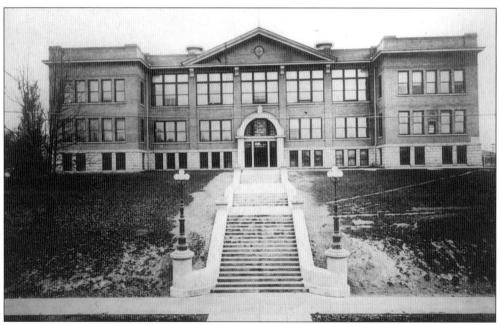

The spacious Chippewa Falls High School, built in 1906 on the hill above Cedar and Bay Streets, witnessed many students pass through its doors. A vocational school was added as a wing to the high school in 1938. The building was later completely used as a vocational school before being converted to an apartment building. (Courtesy of Rutledge Home.)

Eight
THE FACES OF
CHIPPEWA FALLS

The past does indeed matter to us, because it helps to explain how and why we got to be where we are. Pictures are the tools we use to remember the "before," the people who made up the diverse population of Chippewa Falls and who created the community in which we live presently. They are Native Americans, Metis, French Canadians, Scot-Irish Canadians, Norwegians, Germans, Irish, Eastern Europeans, and others whose faces and experiences tell us how very different their world was and, in doing so, help us to remember a past that shaped who we are today.

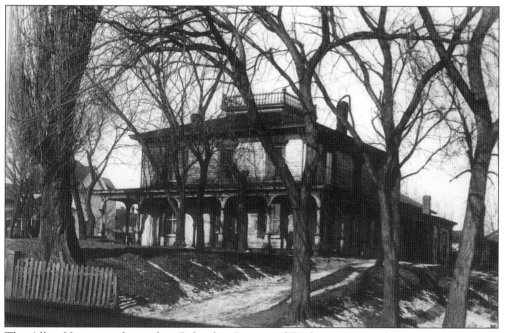

The Allen House was located at Columbia Street and Rushman Drive, the current location of Pederson-Volker Funeral Home. The home was patterned after the Villa Louis, the home of Hercules L. Dousman of Prairie du Chien. In the 1930s, the house was demolished. Mrs. W.C. Ginty and Mrs. Charles Mandelert of the historical committee for the Chippewa Women's Club wrote, "It has been a disappointment to many that the old Allen house was not preserved by the city or county as a public museum. (Courtesy of CCHS.)

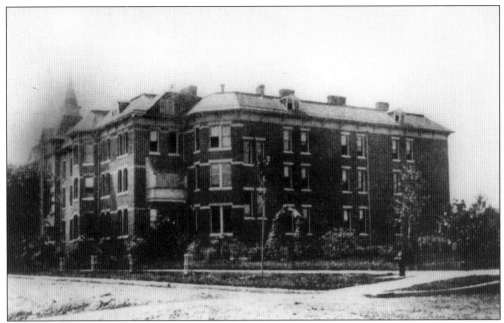

The Hospital Sisters of St. Francis sent Sister Rosa and three other sisters to Chippewa Falls in June 1885 to a small home, their first hospital on Rural Street, to nurse the sick and care for men from the lumber camps. In 1888, a three-story hospital was started at 912 Pearl Street and included patient-care rooms, a chapel, laundry, and kitchen. St. Joseph's Hospital provided continuous medical care at that site until a new hospital was constructed in 1975. The original hospital was converted into the St. Joseph's Apartments. (Courtesy of St. Joseph Hospital.)

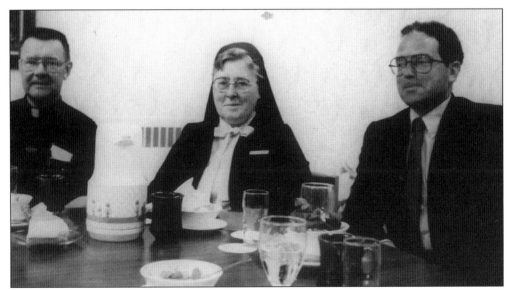

The Hospital Sisters of the Third Order of St. Francis have lived in the United States, Europe, China, Japan, Taiwan, and Chippewa Falls, Wisconsin. Their tradition of caring has been exemplified by (left to right) Father Mike Schelble, longtime chaplain; Sister Frances Elizabeth Schmitz, former hospital administrator and current Hospital Sisters historian; and David Fish, Executive Vice-President and Administrator since 1983. (Courtesy of CCHS.)

Edward Rutledge, a lumberman and a real estate broker who sold his property to the Hospital Sisters of St. Francis to build the hospital, was one of the most generous and forward thinking early residents of Chippewa Falls. His legacies are the Rutledge Home for the Aged and the Edward Rutledge Charity Foundation for the "worthy poor." (Courtesy of CCHS.)

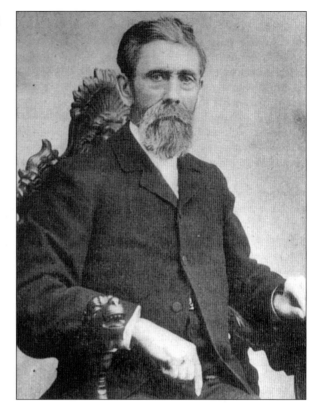

Hannah Rutledge, born in Sherburn, New York, was a widow with one son when she met Edward Rutledge, a timber cruiser, who boarded in her home. Considerate of those around her and concerned about the needs of the poor, when she preceded her husband in death in 1910, Edward Rutledge constructed the Hannah Rutledge Home for the Aged in her memory. (Courtesy of CCHS.)

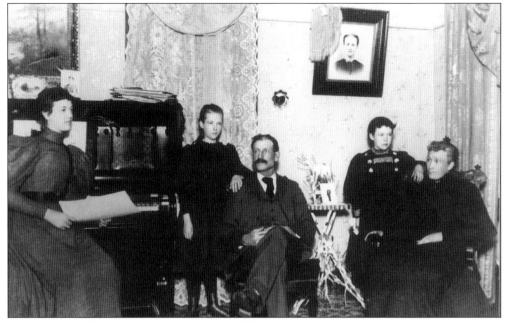

Simon C.F. Cobban, born in Quebec, Canada, served in the Civil War and was involved in the city's primary processing industries including flour, wool, and lumber milling. Responsible for the building of the Opera House in 1880, he also was an organizer and first president of the Northwestern State Bank. The Cobban family home was built in the Queen Anne style at Three Park Place. (Courtesy of CCHS.)

A.J. Post was a wholesale grocer who, in partnership with Leslie Willson, organized and operated the Chippewa Valley Mercantile Company. Incorporated in 1890, it was one of the oldest business institutions in Chippewa Falls. (Courtesy of Delores Beaudette.)

Judge Dayton Cook, born in 1873, earned his law degree in 1895. He was a distinguished lawyer and the district attorney for six years before being appointed judge. Dayton and Florence Stanley Cook were the parents of Stanley, Mabel, and Maurice. (Courtesy of CCHS.)

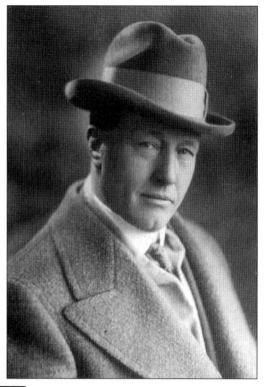

Mabel Cook, daughter of Dayton and Florence Cook, lived with her brother, Maurice, in the family home, the Cook-Rutledge Mansion. A historian and storyteller, she wrote several short stories based on her family's history and shared them at family gatherings. In 1973, Mabel Cook sold the Cook-Rutledge Mansion to the Chippewa County Historical Society. (Courtesy of CCHS.)

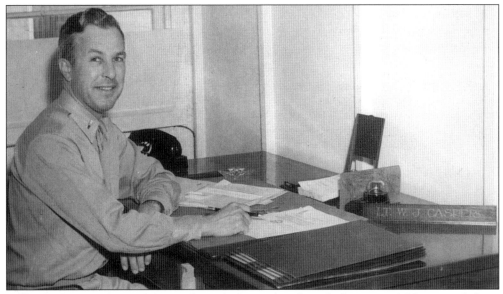

William Casper, the grandson of Jacob Leinenkugel and the son of Henry and Rose Leinenkugel Casper, was first employed by the First National Bank in Chicago before joining the Jacob Leinenkugel Brewing Company in 1933. After serving in the Air Force during World War II, he married Gertrude Treis in April 1948. A generous gentleman, William Casper supported St. Joseph's Hospital, created the Casper Scholarship Fund, and with his wife, Gertrude, funded the Casper Park recreational facility. (Courtesy of CCHS.)

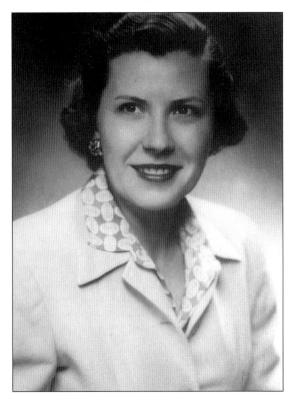

Gertrude Casper was an interior decorator in Milwaukee prior to her marriage to William Casper in April 1948. An accomplished acrylic painter and an avid seashell collector who donated her collection to the Chippewa County Historical Society, she joined her husband in generously contributing to the projects and charities of Chippewa Falls. (Courtesy of CCHS.)

Samuel Jenkins, who was born in Weymouth, England, in 1849, came to Chippewa Falls in 1882 to join his brothers George and Rufus in operating the Jenkins Brothers Store. The store, completed in 1905, featured a Lampson pneumatic cash tube system for the purpose of making charge. (Courtesy of CCHS.)

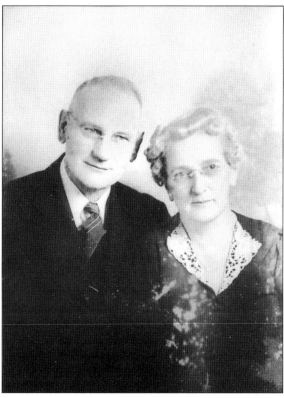

Mr. and Mrs. P.A. Brunstad were owners of one of the most outstanding commercial enterprises, Brunstad Jewelry Store, located in the Hotel Northern building. The Brunstads were active workers for civic advancement, and P.A. Brunstad served as president, vice-president, and secretary of the Progressive League. (Courtesy of CCHS.)

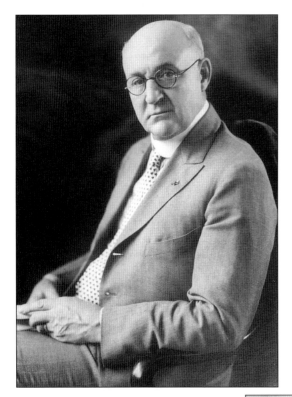

Dr. John David McRae, associated with St. Joseph's Hospital from its inception, was the physician for the Omaha Railroad, Northern States Power Company, and the Wisconsin Telephone Company. Described as an easy man to love and difficult to forget, he was a director of the Lumberman's National Bank and involved in many community activities. (Courtesy of Rutledge Home.)

Lillian Early McRae, the wife of Dr. John McRae and the mother of Donald and Mary Ann, lived with her family on Pond Street along Duncan Creek. (Courtesy of CCHS.)

Rouject D. Marshall, a businessman who promoted the early development of Chippewa Falls and a lawyer of high moral character, was elected to the Wisconsin Supreme Court in 1889, and served until 1917. A benefactor of the city, he donated land along Duncan Creek for a public playground and created the first endowment to St. Joseph's Hospital. (Courtesy of CCHS.)

James Monroe Bingham served Chippewa Falls as a lawyer, a council member, mayor in 1883, and in the Wisconsin Assembly, where he was elected lieutenant governor. His home, built in 1873 and purchased by Edward Rutledge, became the Cook-Rutledge Mansion. (Courtesy of Rutledge Home.)

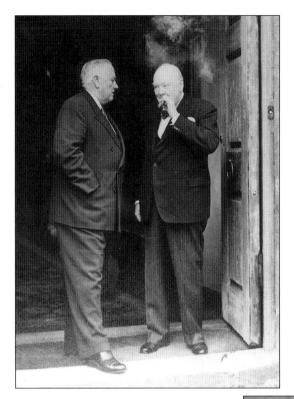

1n 1954, Senator Alexander Wiley, Chairman of the Senate Foreign Relations Committee, was invited by the Rt. Honorable Sir Winston Churchill to lunch with him at his estate in Sussex, England. Alexander Wiley was born in 1884 in Chippewa Falls, where his father owned the Norway House. He served four terms in the United States Senate and was known as the Father of the St. Lawrence Seaway. (Courtesy of Evalyn Frasch.)

Three distinguished members of the Chippewa Falls legal community were Judge Clarence Rinehard, Judge Marshall Norseng, and Attorney Henry Christoffersen. (Courtesy of Charles Norseng.)

John Campain came to Chippewa Falls in 1855. After working as a pilot on the river near the Falls, he operated a stagecoach between Chippewa Falls and Flambeau for 25 years. (Courtesy of Chippewa Falls Public Library.)

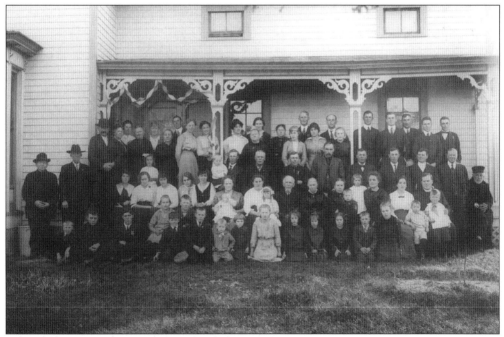

The 50th wedding celebration of Nicholas and Magdalene Meinen was held at the Meinen home in Tilden, where the family of eight had farmed since Nicholas, a native of Germany, settled before Chippewa Falls was founded. (Courtesy of CCHS.)

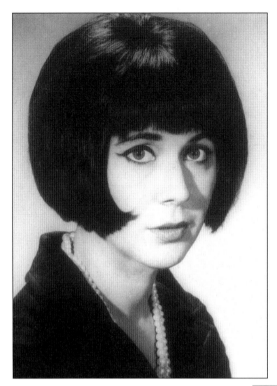

Judy Henske, a graduate of McDonell High School, was a folk singer, songwriter, and dubbed the "Queen of the Beatniks" during her early career. She was the Midwestern inspiration for good friend Woody Allen's movie *Annie Hall*. Married to Jerry Yester of the "Lovin Spoonful" band and the mother of Kate Yester, Judy Henske recently released her first album in 28 years entitled *Loose in the World*. (Courtesy of CCHS.)

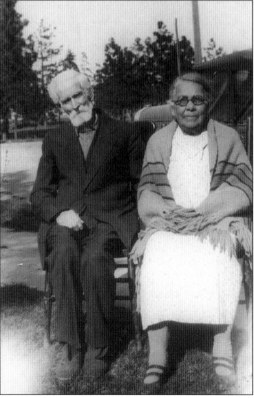

Myron Martin, "a blue bellied Yankee" from Binghamton, New York, and Sophie LaRush Martin, a direct descendant of Michael and Madeline Cadotte, were married in 1972 by Father C.F.X. Goldsmith in Chippewa Falls. Descendants of their family continue to live in the Chippewa Falls area today. (Courtesy of Marge Hebbring.)

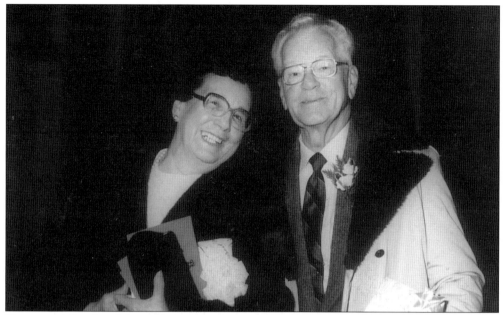

Kermit and Caroline Martin Benson were married in April 1947. Kermit sailed for eight years as an engineer on the Great Lakes. An avid muskie fisherman, an environmental activist, and a leader in the fight to stop the mining of sulfide deposits, he was inducted into the Muskie Hall of Fame in 1992. Caroline, a direct descendant of Michael and Madeline Cadotte and an enrolled member of the Lac Courte Oreilles band, wrote and published numerous poems and stories for her children and grandchildren. (Courtesy of Marge Hebbring.)

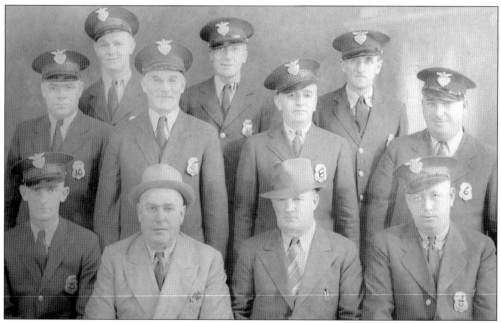

Edward Holtz (first row, third from left), a continuous resident of Chippewa Falls except for time spent in service and captain of the police department since 1928, is pictured with 10 officers in 1935. (Courtesy of Rutledge Home.)

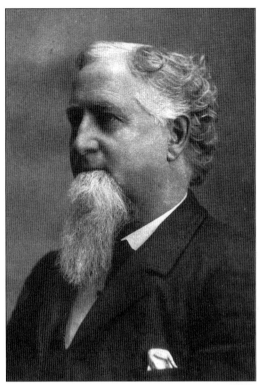

By an act of legislature in the spring of 1870, the City of Chippewa Falls was granted a charter, whereby the Village of Chippewa became the City of Chippewa Falls. James A. Taylor was elected the first mayor of Chippewa Falls. (Courtesy of Rutledge Home.)

Virginia O. Smith served on the city council from 1982 until 1991, when she was elected the first female mayor of the City of Chippewa Falls. She is in her sixth term—the city's longest serving mayor. Active in community affairs, she is an ardent advocate of the Chippewa Falls community, as were so many of her predecessors. (Courtesy of CCHS.)

Morris Poznanski was born in 1872, in Chippewa Falls. After continuing his education in Milwaukee, he returned to Chippewa Falls to oversee his father's business, Poznanski's Dry Goods Store. He organized the Chippewa Glove and Mitten Factory, the Handmade Shoe Company, and the Chippewa Canning Company. In 1909, he purchased the bankrupt Chippewa Furniture Company for his brother, Jay. Morris was elected mayor twice. (Courtesy of Rutledge Home.)

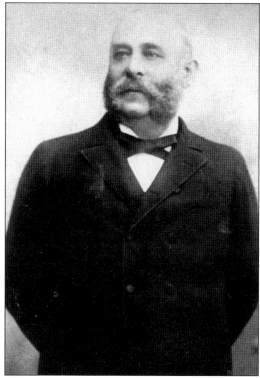

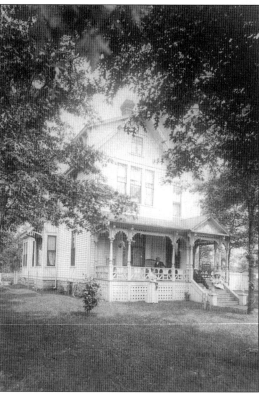

The Henry and Hannah Allen Buell house, known historically as the house of Hiram S. Allen's daughter at 810 West Willow Street, was built in 1881 for Amund Meyer at a cost of $3,500. Stained glass windows, an unusual shed, a roofed dormer, and an open porch characterize the house. (Courtesy of CCHS.)

Leslie Willson was born in Pennsylvania in 1847. Traveling west to Wisconsin, he was associated with the Eau Claire Lumber Company and the firm of Bell, Conrad & Company before he organized the Chippewa Valley Mercantile Company. Solely responsible for eliciting support for a library from Andrew Carnegie, Willson was one of Chippewa Falls' great benefactors. (Courtesy of Rutledge Home.)

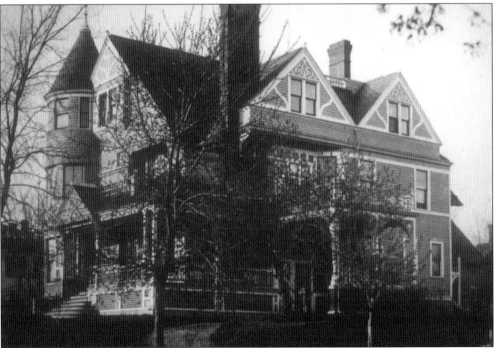

The Leslie Willson home on Superior Street is historically significant as a visual representation of the West Hill neighborhood. (Courtesy of Delores Beaudette.)

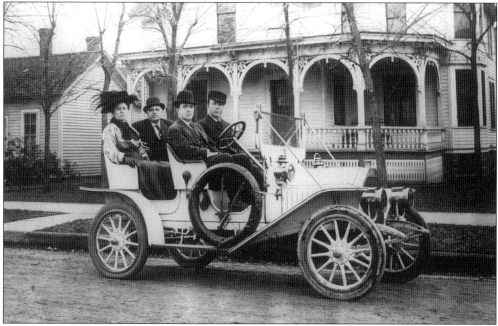

At 420 Bay Street, the home of Mr. and Mrs. D.O. McQuire, pictured with Thomas and Edward Crooks, is now the Horan Funeral Home. (Courtesy of CCHS.)

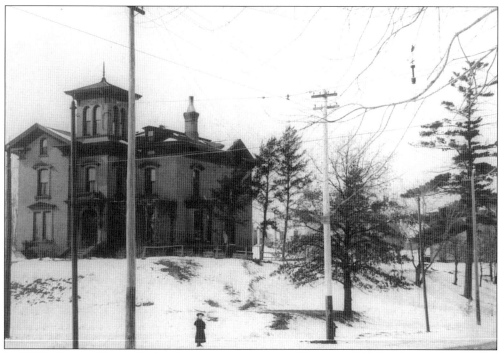

In 1873, George Winans built a house on the corner of Bridge and Cedar Streets. It was later owned and occupied by William Irvine and Thaddeus Pound. In 1906, the Chippewa Falls High School was erected in this spot, and it later became District One Technical Institute. It is presently the site of the Bridge Place Apartments. (Courtesy of Rutledge Home.)

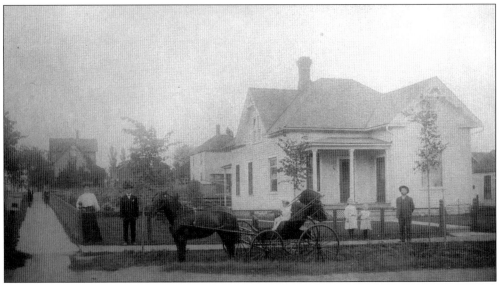

The horse and buggy in front of the William Misfeldt home at 19 North Grove Street in 1907 stands ready for Irene Misfeldt, William Misfeldt, Hilda Misfeldt, and Fred Dubhok Jr. (Courtesy of CCHS.)

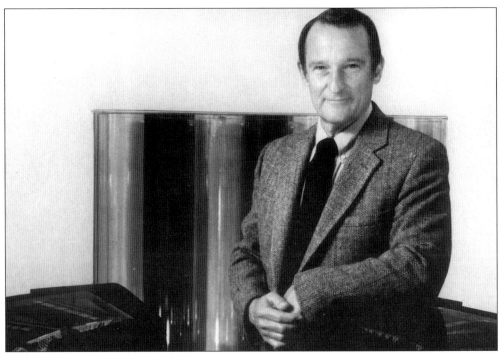

Just as the pioneers used the technology of water power to build the logging industry, Chippewa Falls native Seymour Cray Jr. used electronic technology to create an electronics industry, Cray Research, in Chippewa Falls. The Cray 1 computer system, designed in 1974, is exhibited at the Smithsonian Institute. The Chippewa Falls Museum of Industry and Technology houses the only complete collection of Seymour Cray supercomputers in the world. (Courtesy of Chippewa Falls Area Chamber of Commerce.)

Nine

WHAT'S THERE TO DO HERE?

During the earliest days in Chippewa Falls, there was little idle time and what to do was seldom an issue. However, when Dan McCann began to play his fiddle, floors in boarding houses or stores were quickly cleared for dancing. Churches provided opportunities for entertainment, and plays were presented at Hook's Hall and the Opera House. During the long winters, ski jumping near Summit Avenue and bobsledding down Columbia Street Hill were exciting adventures for adults and children. Some preferred to play cards, while others went to one of three movie houses. Fishing, bowling, and skating were also popular. Secret and benevolent societies seemed inclined towards costume parties, and the much anticipated Northern Wisconsin State Fair attracted large and enthusiastic crowds. Since everybody loves a parade, there were numerous opportunities to celebrate with parades on Bridge Street, a tradition the community enjoys to the present day.

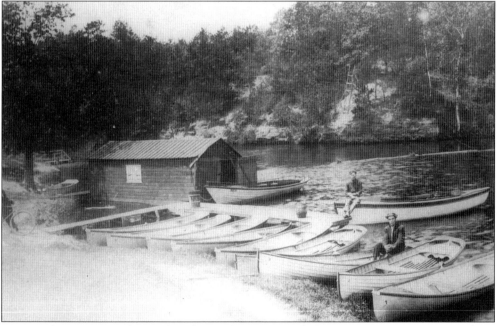

Eric Lueck's Boat Rental near the Glen Loch Dam provided opportunities for boaters to enjoy the lake. Glen Loch was offered by its owner, Consolidated Milling Company headed by Alexander McDonell, to Irvine Park for boating and picnic purposes in the summer and for ice sports in the winter. (Courtesy of CCHS.)

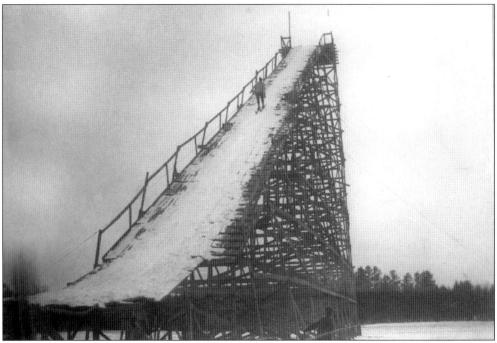

The Chippewa Falls ski jump scaffold was a model for the sport across the nation. The North Star Ski Club was prominent in making the sport popular in America. The Annual Ski Tournament in January 1912 had 70 entries. (Courtesy of Delores Beaudette.)

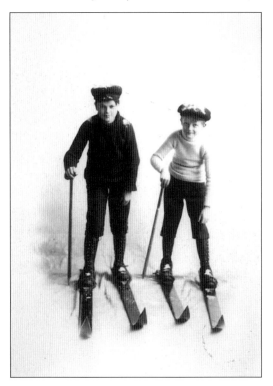

John Myrman and Ted Larson were posed for this 1903 picture in the Bish studio. The sheet forming the backdrop had holes cut for the back of the skies. After posing the boys, Mr. Bish went outside to get snow to put on top of their caps. (Courtesy of Chippewa Falls Public Library.)

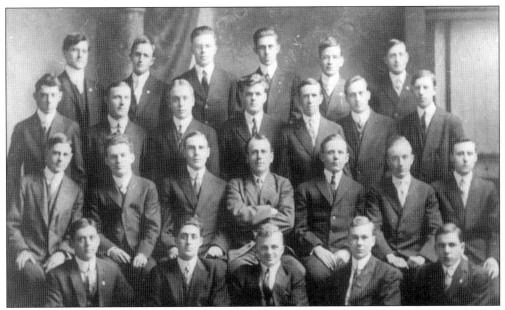

The Hikers Club was a group of young men who made long walks during the weekends from Chippewa Falls to neighboring towns. Pictured in 1914, are, from left to right: (front row) Victor Charland Jr., William Cardinal, Fred Stumm, Walter Schaller, Chris Ek; (second row) Arthur Ek, Harry Nicolai, Arnold Berg, Joseph Gailloux, Elmer Adams, Henry Reden Jr., and Dave Paquette; (third row) Erwin Phelps, George Koep, John Oie, Don Thomas, Frank Proulx, Carl Linden, and Barney Halvorsen; (fourth row) Charles Cournoyer, Joseph DeLisle, Norman Brown, Sever Remol, Albert Barret, and Peter DeLisle. (Courtesy of CCHS.)

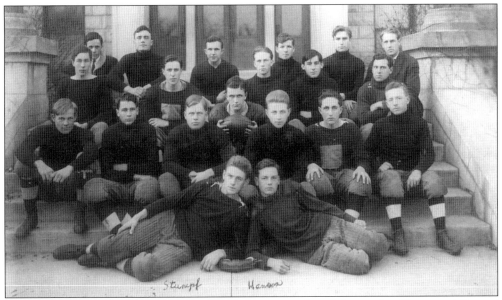

Players on the 1912 Chippewa Falls football team were, from left to right: (front row) Stumpf and Hanson; (second row) Pederson, Stafford, Anderson, Hoenig, Miller, Hart, Flug; (third row) Stafford, Stafford, Swenson, Camastral, Charland; (fourth row) Hayes, Thompson, Cummings, Gerber, Law, Findley, and Coach. (Courtesy of Rutledge Home.)

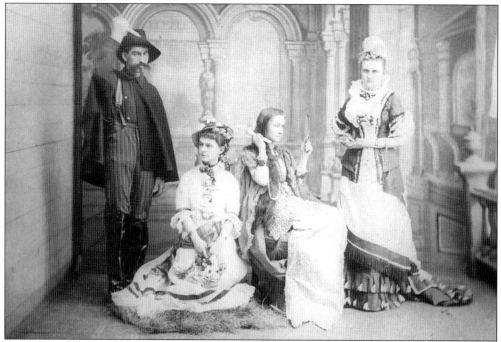

"Mrs. Jarley's Wax Works," a theatrical performance given in April 1879 in Dramatic Hall for the benefit of the Ladies Aid Society of the Episcopal Church included, from the left: Homer Pound, father of Ezra Pound, as the villain; with Mary Patten; Lucy Patten; and Frances Ginty. (Courtesy of Christ Episcopal Church.)

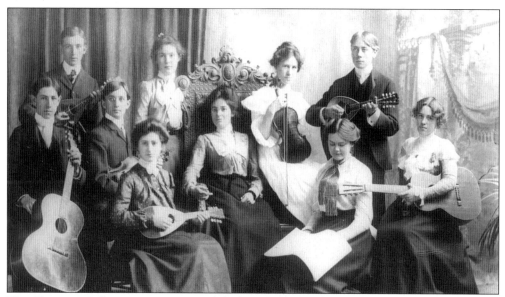

The Chippewa Falls community enjoyed the music of the Mandolin Club in 1903. Members of the club were, from left to right: (front row) Aimee Rowe (Mrs. Frederick Burgh), Majorie Hurd (Mrs. Charles Barker), Adelaide Miller; (second row) Frank Phillips, Earl Baker, Miss McMillian, Directress; (third row) Harry Favell, Florence McLaren (Mrs. John Nibbe), Amanda Caesar, and Alexander Wiley. (Courtesy of Delores Beaudette.)

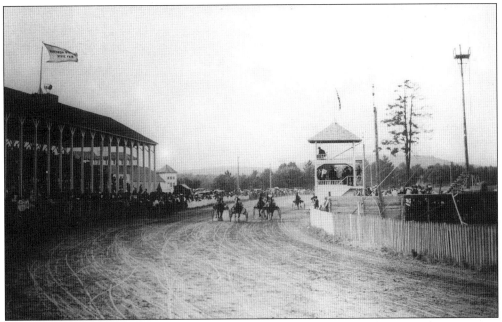

The largest single entertainment event in the city was the Northern Wisconsin State Fair, held on the site belonging to the Chippewa Falls Driving Association, a horse racing circuit. Harness racing in front of a grandstand that could hold 4,000 people was a special attraction in 1909. (Courtesy of CCHS.)

The fair was originally organized and run by the Chippewa County Agricultural Society from 1877 until 1895. The Northern Fair Association took over until 1934, when a group of 12 investors purchased the grounds and reopened the "Northern Wisconsin District Fair." (Courtesy of CCHS.)

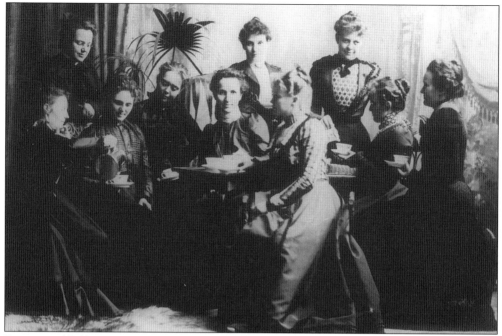

Dances and balls were popular during the turn of the century when these debutantes gathered for tea in 1903. (Courtesy of CCHS.)

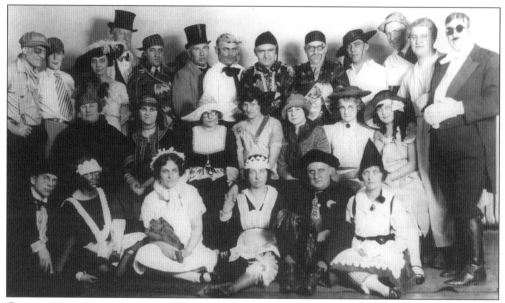

Costume parties were a source of entertainment and amusement. Elks Club members who dressed for this occasion, c. 1920, are, from left to right: (front row) Frank McCarthy, Gena Larrabee, Elizabeth Ainsworth, Aurora Williams, Walter Larrabee, Bev Emerson Larrabee; (second row) Kelly, Stella Fletcher, Bower, unidentified, Mary Jane Olson, Virginia Howie, Minta Martin, Irene Casper Hebert; (third row) Archie Fletcher, unidentified, Agnes Mason McCarthy, unidentified, Frank Martin, Louis Olson, unidentified, Charlie Arnsworth, Robert Wiley, Orrin Larrabee, and Charles Hebert. (Courtesy of CCHS.)

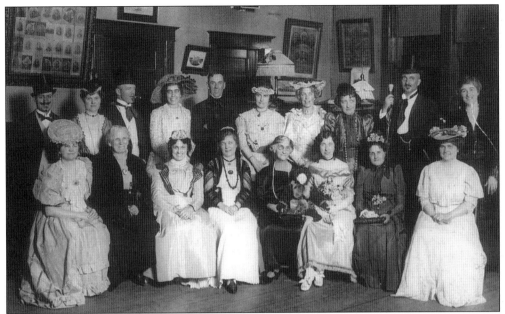

Secret and benevolent societies held parties in their respective halls. Enjoying the costume party in 1924 at the Odd Fellows Hall are, from left to right: (first row) Gena Larrabee, Mrs. Wands, Florence LeTendre Lund, Irene Casper Hebert, Mrs. M.S. Bailey, Mrs. Aurora Williams, unidentified, unidentified; (second row) unidentified, unidentified, unidentified, Mary Nimmons, unidentified, unidentified, unidentified, Margaret Duren, and Earl Baker. (Courtesy of CCHS.)

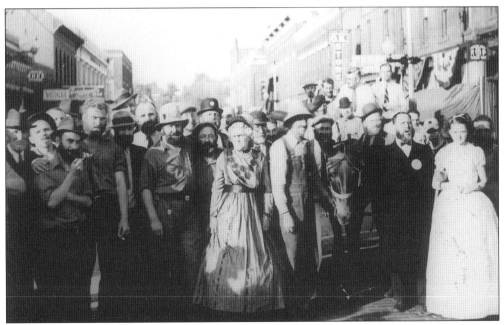

Parades were community events, and the Chippewa Falls Centennial Parade in 1937 attracted thousands to the downtown area, many of whom dressed for the occasion. (Courtesy of Rutledge Home.)

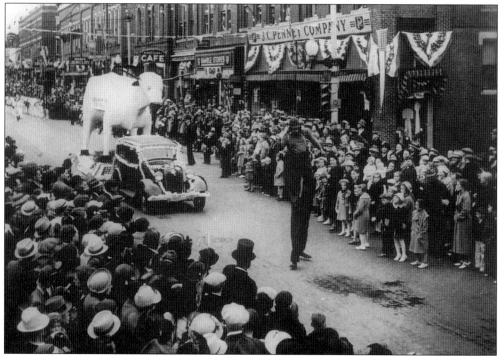

Lawrence "Tony" Vincent dressed as lumberjack Paul Bunyan for the 1937 Centennial Parade. (Courtesy of Yvonne Brunstad.)

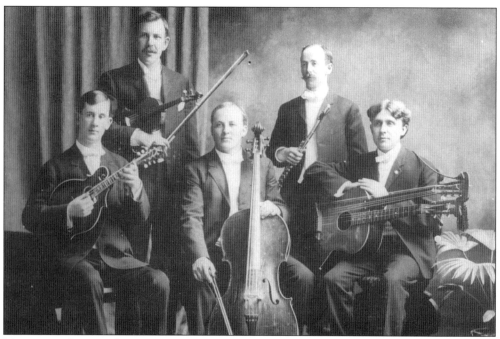

Music was always a favorite form of entertainment, and the Peerless Orchestra gave many concerts in the city. Pictured in 1908 are, from left to right: Jack Ermatinger, Charles Strong, Rudy Emerson, Tom Phillips, and Radke. (Courtesy of Rutledge Home.)

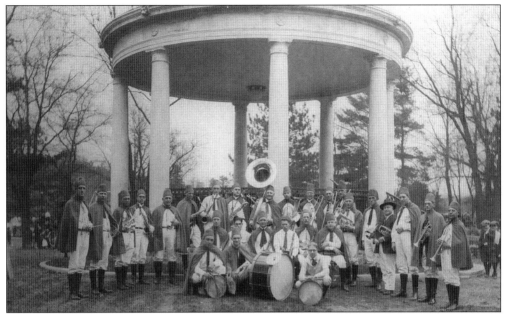

The Knights of Pythias Bank performed at the dedication of the Irvine Park Memorial Bandstand in 1924. Directed by Dr. D.G. Smith, they played songs from *King Lear* and marches by Sousa. William Irvine frequently requested the band to play his favorite, *The Bells of St. Mary's*. (Courtesy of CCHS.)

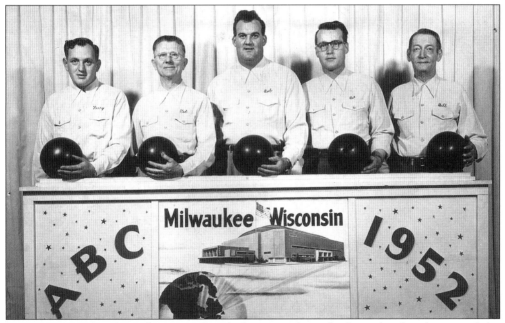

In 1916, a new bowling alley opened with four new "loop the loop" bowling lanes, and the proprietors were planning to make bowling one of the most popular sports. In 1952, these five Chippewa Falls bowlers participated in a tournament in Milwaukee. They are, from left to right: Harry Eystad, Ted Willenbockel, Bob Moe, Pat Garvey, and Bill Dreher. (Courtesy of Rutledge Home.)

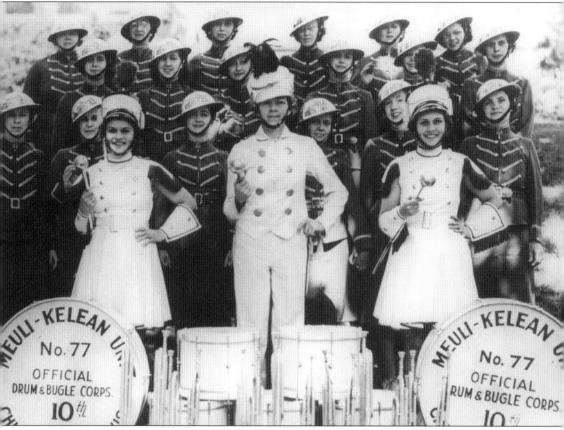

The Meuli-Kelean Unit #77 Drum and Bugle Corps, organized in 1935 and comprised of women of all ages, was trained to march by the American Legion. Rose Greenwood played the bass drum, and her daughter, Sis McCarthy, was one of the drum majorettes. Making appearances around the state, the corps won the state championship in 1935 and 1936, before disbanding in 1948. (Courtesy of Bob Gardner.)

Ten

BACK TO OUR ROOTS

Downtown, nestled between the Chippewa River and Duncan Creek, is where our community began. Impressive structures were built to reflect the strength and integrity of the community and its founders. The downtown commercial district offered a full line of retail products and services. Family owned businesses and several department stores were located here.

People were much more mobile following World War II, when the automobile became more affordable. Travel beyond the local community became more common. Modern shopping centers were built along highways catering to motorists. Many retail businesses followed this trend and moved out of downtown to these new automobile-oriented locations. Downtown buildings were "modernized" to attract new tenants or removed to make room for new development. A federal government program called the Urban Renewal Program provided funds to cities to clear blocks of older buildings in many downtowns. Much historic architecture was lost to the wrecking ball during this period.

In the 1980s, the National Trust for Historic Preservation created the National Main Street Center to educate community leaders about the benefits of historic preservation and the rejuvenation of our nation's downtown commercial districts. Wisconsin joined the Main Street movement in 1988, by creating a program to educate communities about the "Main Street Approach." Chippewa Falls applied to join the program in 1989, and was accepted. Three years of training about the "Main Street Four Point Approach" created a grass root, volunteer driven movement to revitalize Downtown Chippewa Falls and to improve the community's quality of life. The four points are organization, promotion, design, and economic restructuring.

Chippewa Falls Main Street, Inc., through dedication, innovation, and hard working volunteers and staff gained recognition for its successes. Business and job growth as well as investments in restoration projects and new construction projects has reached more than $57 million, which is approximately 11 times the national Main Street average. Since the creation of the Main Street program in Chippewa Falls, there has been an increase in the appreciation of historic architecture. Many building facades have been restored, and buildings have been saved from demolition and put back into productive use for community residents and for future generations.

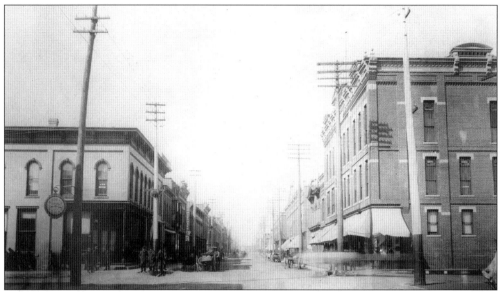

This 1910 view of Bridge Street looking north from Spring Street shows a portion of the Bridge Street Commercial Historic District that is listed in the National Register of Historic Places. Since Main Street had the district listed in 1994, some building owners have utilized the National and Wisconsin Historic Preservation Tax Credits available for National Register building restoration projects. (Courtesy of CCHS.)

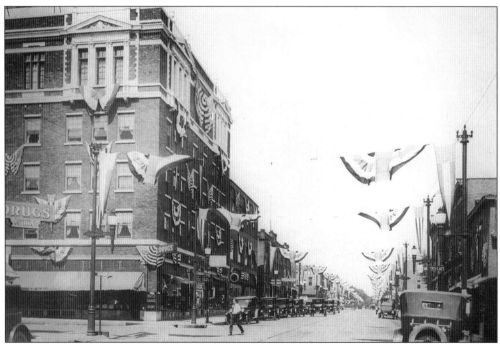

Looking north from Grand Avenue, the Northern Hotel and Bridge Street are decorated patriotically on July 4, 1921, to commemorate the raffling off of the Northern Hotel in a nationwide lottery. The State of Wisconsin declared the lottery illegal in 1922. (Courtesy of CCHS.)

The first visitor information center opened May 15, 1939. It was located on the southwest corner of Bridge and River Streets, in the same location as the current visitors center. The 10-by-14-foot building was log sided and had a muskellunge concrete retaining pond built to the south of the center. (Courtesy of CCHS.)

The grand opening for the new visitors center was on August 5, 1999. Along with a visitor information area, the building provides a joint office facility for the Chamber of Commerce, the Chippewa County Economic Development Corporation, and Chippewa Falls Main Street. (Courtesy of CFMS.)

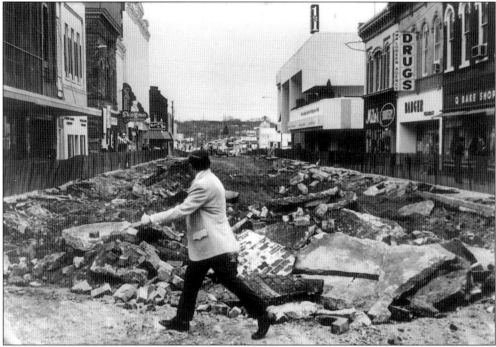

Looking south on North Bridge Street from Central Street in 1976, modernized building facades and a marked increase in projecting signs are visible. Loose bricks from the torn up street make way for new streetscape and utility improvements. Bridge Street was closed seven months during the project. (Courtesy of CVM.)

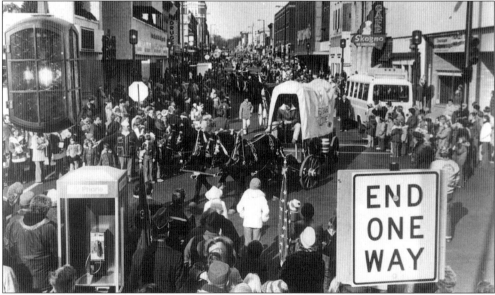

Facing north on Bridge Street from Spring Street in 1976, a parade celebrates the reopening of the street. New historic styled streetlights are located between the taller modern streetlights. New water, sewer, telephone, electric, and gas utilities were installed beneath the new pavement. The city removed the downtown parking meters in 1981. (Courtesy of CVM.)

116

Jayson Smith was hired in 1981 as the first Chippewa Falls City Planner. He was aware of the new state legislation enabling the creation of Business Improvement Districts (BID) to fund downtown revitalization programs. After much research and input from businesses, a BID was created in 1988, and a downtown market analysis was completed. (Courtesy of CFMS.)

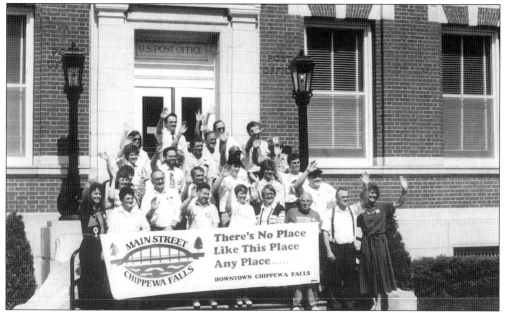

Chippewa Falls applied for acceptance into the Wisconsin Main Street Program, and the application was approved. Kathy La Plante (front row left) was hired as the first Main Street director. Kate Lindsay (front row right) was elected as the first Main Street president. Main Street volunteers show their enthusiastic support in this photo. (Courtesy of CFMS.)

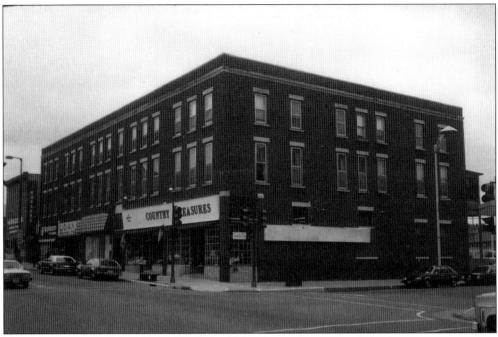

Built about 1880, the Cobban Block building, located on one of the busiest intersections downtown, housed a variety of retail businesses and 14 apartments. (Courtesy of CFMS.)

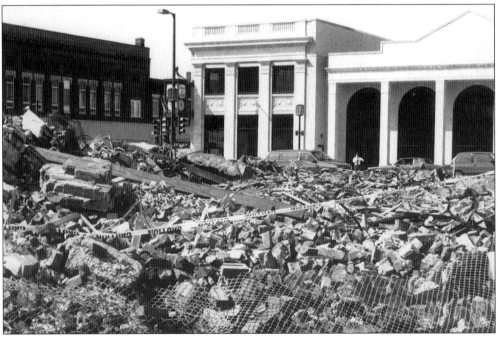

Rubble in the foreground is all that remained of the Cobban Block following a devastating fire March 14, 1991. Now this grass-covered lot is used for Main Street special events, including the Farmers Market. Redeveloping this site continues to be a goal. Across the street is Northwestern Bank, which was chartered in 1904. The corner building was built in 1924, and the architecturally compatible addition on the right was built in 1990. (Courtesy of CFMS.)

118

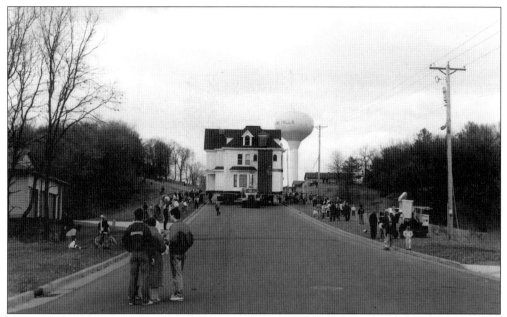

The Grossman house, built in 1906 in the Georgian Revival architectural style, was moved in June 1991 to a new location on the west side of town. Rather than building in another location, the city and Main Street encouraged the county to build a $9.1 million courthouse expansion downtown. The expansion threatened the Grossman house, and after much effort a new owner was found who moved and restored the home. Another downtown $10 million courthouse expansion is currently being added. (Courtesy of CFMS.)

The 100-plus-year-old carding machine at Kay's Nine Patch Quilts-n-Crafts (Chippewa Carding Mill) is one of only five carding mills still operating in the United States. The business is owned by Kay Hanson and located at 17 West Central Street. The owner of the building and carding machine, David Raihle Jr., is planning on historically restoring the building façade. (Courtesy of CFMS.)

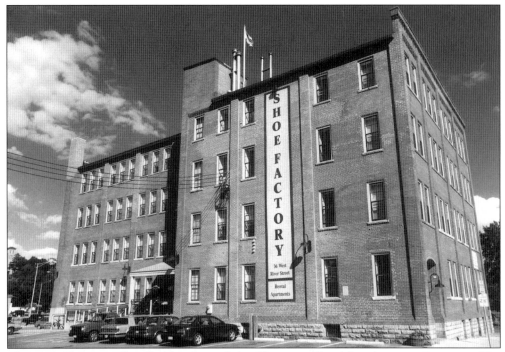

The 1910 Chippewa Shoe Building housed the Chippewa Shoe Manufacturing Company. The factory employed 175 workers and produced 1,500 pairs of shoes daily prior to closing in the late 1980s. The building sat vacant and was felt to be the city's worst eyesore. Several unsuccessful attempts had been made to reuse the building until developer Warren Loveland came to town in 1993. With financing help from the city and Main Street, the project produced 23 new downtown living units. (Courtesy of CFMS.)

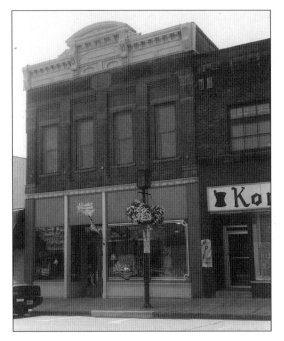

The building currently occupied by Country Treasures at 216 North Bridge Street was built in 1889, for Felix Cardinal and Charles Bergeron as a saloon. One hundred years later, Joyce Pugh, the owner of Country Treasures, took the lead and was the first building owner in downtown Chippewa Falls to historically restore her building. (Courtesy of CFMS.)

The Union Block, 123 North Bridge Street, was built in 1885 and designed by the most prominent local architect, Samuel Snyder. During the "modernization period," a metal mesh covering was installed to the upper façade. Aluminum framed windows and aluminum awnings were also installed. (Courtesy of CFMS.)

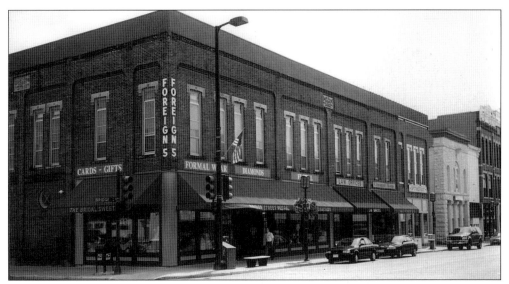

Current owners of the Union Block, members of the law firm of Wiley, Colbert, Norseng, Cray, and Herrell, restored the building exterior. The upper floor metal screening was removed in 1995. During the winter of 1998, the weight of ice buildup on the metal awning brought it crashing down, shattering the display windows. They were replaced with more original styled wood frame doors, windows, and canvas canopies. (Courtesy of CFMS.)

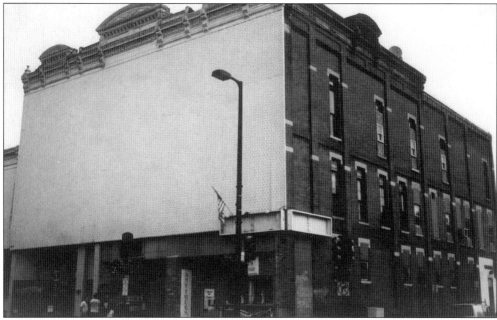

Another metal "slip cover" obscures the two upper stories of the Metropolitan Block at 101 North Bridge Street. The original first-floor storefront had been completely removed and replaced with stone material that was inappropriate for use with this style of architecture. (Courtesy of CFMS.)

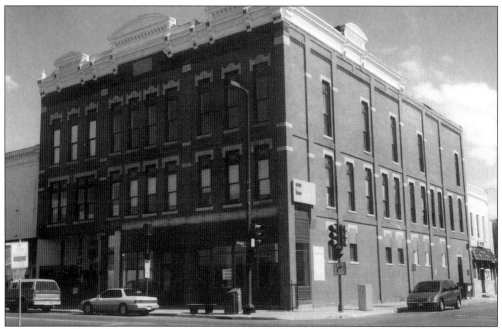

Restoration of the 1888 Italianate influenced commercial three-story Metropolitan Block was one of the most noticeable downtown building transformations. The interior of the building was also restored or sensitively renovated. Owner Jeff Novak began this multiple year project in 1994. (Courtesy of CFMS.)

Constructed in 1873, the First National Bank building at 111 North Bridge Street was only one story. A second story was added in 1888. Modernization and energy concerns resulted in window size reduction. The building was also painted, and soon thereafter the paint began to peel off the cut sandstone. (Courtesy of CFMS.)

The First National Bank building restoration project began in May 1999. Eric's Diamonds & Fine Jewelry was the first business in Wisconsin to win both the Wisconsin Main Street Award for Best Interior Restoration and the award for Best Exterior Restoration. The owner, Eric Pulver, is still seeking to replace a statue of an eagle that once sat upon a ledge above the second-story windows. (Courtesy of CFMS.)

Beginning in 1993 Chippewa Falls was the first community in Wisconsin to decorate downtown with hanging flower baskets. Chippewa Falls Main Street's innovative projects have earned national recognition. In 1996, the program won the Great American Main Street Award. In 1997, Chippewa Falls was listed as one of America's Top 10 Small Towns in *Time Magazine*, the Best American Small Downtown Newsletter Award was won, and two national publications, *Changing Places: Rebuilding Community in the Age of Sprawl* and *Main Street Success Stories*, featured the program. In 1998, the program's special events were featured in the book *Main Street Festivals*. In 2000, the National Trust for Historic Preservation designated Chippewa Falls one of a Dozen Distinctive Destinations in recognition of historic preservation and downtown revitalization efforts. (Courtesy of CFMS.)

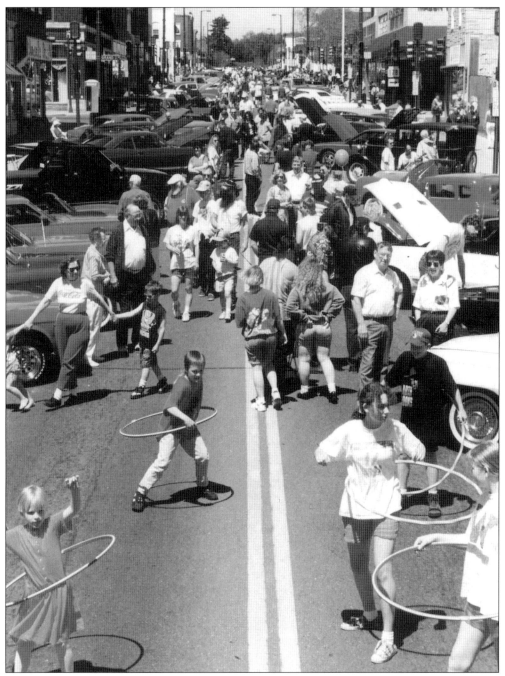

Special events like Main Street's Cruisin' the Years Car Show attracted auto enthusiasts and the general public downtown. Current Main Street annual special events include the Earth Day Downtown Cleanup; the Boat, Camping, and Fishing Swap Meet; the Pure Water Days Heritage Fun Fest; and the weekly Farmer's Market. Main Street also assists retailers in coordinating retail events and purchasing co-op advertising. Current retail events include the Krazy Daze Sidewalk Sale, the Fall Harvest Sale, and the holiday co-op advertising campaign. (Courtesy of CFMS.)

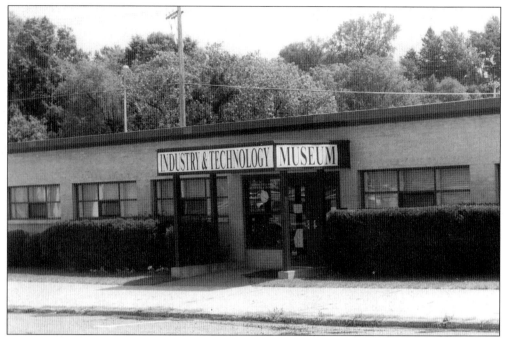

The Chippewa Falls Museum of Industry and Technology opened in 1997 at 21 East Grand Avenue. Exhibits include the world's only Super Computer Collection, created by Chippewa Falls native Seymour Cray. The history of other products "Made in Chippewa" are also exhibited along with hands on science displays. (Courtesy of CFMIT.)

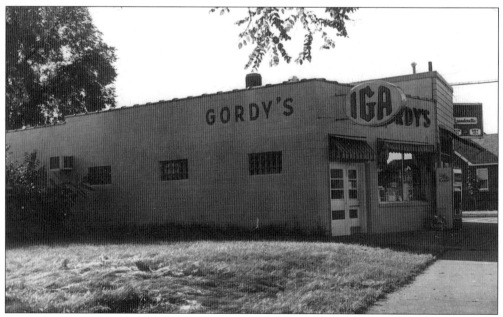

Gordy Schafer, "a hometown boy," started in the grocery business March 11, 1966, in this 2,800-square-foot building at 419 South Main Street. His was the first local grocery store to open on Sundays, and Gordy recalls lines of people at the meat counter after Sunday church services. (Courtesy of the Schafer family.)

Gordy's IGA Plus expansion ribbon cutting commemorated the grand opening of a first-class full-service 52,000-square-foot supermarket in the middle of downtown. This project won the 1998 Wisconsin Main Street Best Business Recruitment/Retention Award. The store has received the highest IGA Five Star Rating in Wisconsin. Pictured participants from left include: Mayor Virginia Smith, Chamber President Mike Jordan, Main Street Executive Director Jim Schuh, and Owner Gordy Schafer. (Courtesy of CFMS.)

Christmas carolers gather on the steps of the Edward Rutledge Charities building, which was transformed by Main Street volunteers into Santa's House. The holiday season brims with old-fashioned activities including Santa's arrival the day after Thanksgiving, Santa's Saturday visits with children at his house, and photos with Santa taken by Mrs. Clause. Horse-drawn wagon rides go through downtown and into Irvine Park, which is decorated as the Christmas Village with tens of thousands of lights. The Bridge to Wonderland Parade, the first Saturday in December, attracts thousands to view the nighttime parade with its lighted floats playing Christmas music. Particularly at Christmas time, Chippewa Falls becomes a shining example of what can be accomplished when individuals, families, organizations, businesses, and industries join together to preserve the uniqueness of this city through which the waters of the Chippewa River continue to flow. (Courtesy of CFMS.)